WILLIAM IVEY LONG

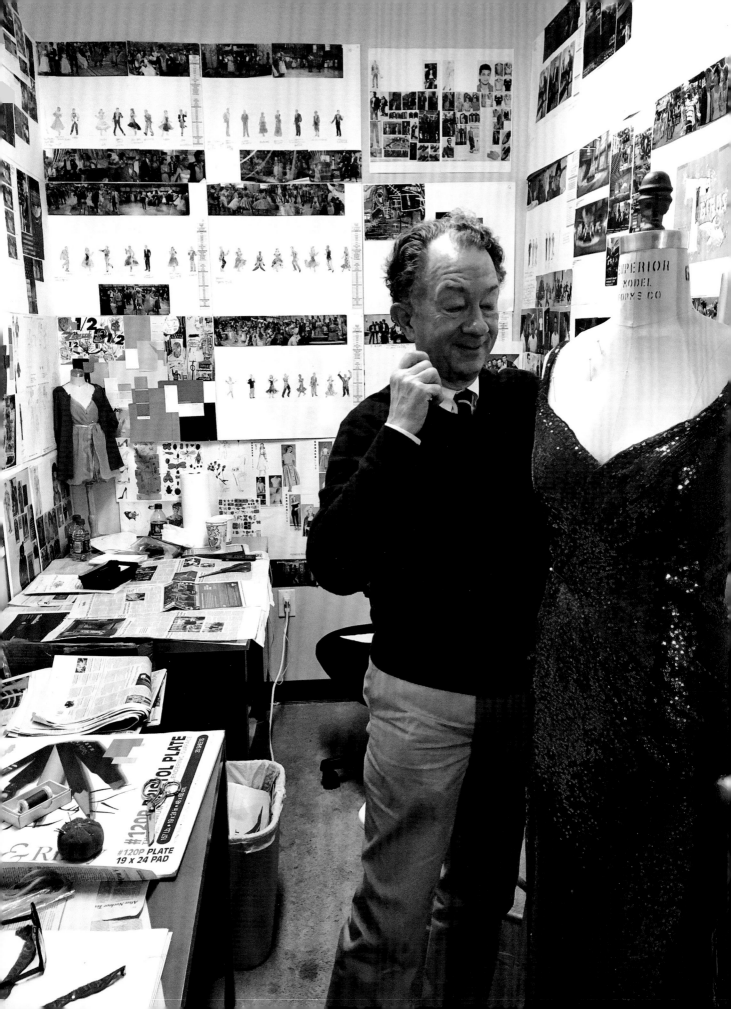

WILLIAM IVEY LONG
COSTUME DESIGNS 2007 2016

ANNIE CARLANO, Editor

with contributions by

PETER MARKS and REBECCA E. ELLIOT

THE MINT MUSEUM

DISTRIBUTED BY YALE UNIVERSITY PRESS, New Haven and London

Published in conjunction with the exhibition *William Ivey Long: Costume Designs 2007–2016* organized by The Mint Museum, Charlotte, North Carolina, September 23, 2017–June 3, 2018

William Ivey Long: Costume Designs 2007–2016 is presented to the Charlotte community with generous support from Wells Fargo Private Bank. Additional support is provided by the Mint Museum Auxiliary and Friends of William Ivey Long.

THE PRIVATE BANK

The Mint Museum is funded, in part, with operating support from the Arts & Science Council of Charlotte-Mecklenburg, Inc.; the North Carolina Arts Council, a division of the Department of Cultural Resources; the City of Charlotte; and its members.

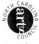
www.ncarts.org

Culture For All.

Library of Congress Control Number: 2017019239
ISBN: 978-0-300-22938-7

Text edited by Donna Ghelerter
Designed by Linda Florio, Florio Design

Front cover: Costume for Katelyn Prominski as Etoile (detail), "The Courtship of Petipa," *Little Dancer*, 2014. Photograph by Irving Solero
Frontispiece: William Ivey Long on the set of *Grease Live!*, 2016. Photograph by David Korins
Page 128: Long family crest, designed by William Ivey Long and drawn by Sir Henry Edgar Paston-Bedingfeld, 2014

Published by The Mint Museum
2730 Randolph Road
Charlotte, North Carolina 28207
mintmuseum.org

Distributed by Yale University Press
302 Temple Street
New Haven, Connecticut 06511
yalebooks.com/art

Printed in the United States by GHP, CT

CONTENTS

Sponsor's Statement

Architects, sculptors, and painters have long used line, color, material, pattern, and texture to create incredible works of art. Fashion designers use these same design elements to craft wearable art that comes to life on the human form. With the exhibition *William Ivey Long: Costume Designs 2007–2016*, the Mint continues to help us explore the application of these fundamental design concepts to costume. In a world where the runway and red carpet constantly collide, where celebrity and theatricality go hand in hand, and where fashion and fantasy are at times one and the same, costume is more relevant than ever in the arena of art and fashion.

Wells Fargo is pleased to serve as the presenting sponsor for this exhibition. We celebrate William Ivey Long's Carolina roots and their acknowledged role in his life and career: "You are happier if you know your place" he once said. In an increasingly complex world, Long's sartorial skills bring compelling characters to life and his stunning aesthetics allow us to escape the present and be transported to a different time and place.

Jay Everette
Senior Vice President,
Community Affairs Manager, Wells Fargo

Foreword

The Mint Museum, an institution dedicated to international art and design, continues, through its exhibitions, publications, and programs, to champion a broad range of outstanding aesthetic production. With a strong commitment to contemporary craft and design, we seek to celebrate those makers who combine innovation with a mastery of materials and processes. Our explorations are intentionally inclusive: recent exhibitions have featured tattoos, nail ornamentation, body adornment, high-tech fashions, and food-related objects from chopsticks to tea kettles—installed in magical, immersive environments.

William Ivey Long: Costume Designs 2007–2016 further expands our examination of contemporary design. The exhibition and this accompanying book present Long's oeuvre over the past decade, adding to the narrative of his prolific and prodigious costume production since a retrospective of his career at the Cameron Art Museum ten years ago. Looking at Long's work from a fresh historical perspective in her introductory essay, Annie Carlano, senior curator of craft, design, & fashion, considers the designer's unique upbringing, education, and approach to costuming, and dares to suggest an alignment with fashion design. In his spirited appraisal of Long's contributions to the theatrical world, Peter Marks, chief theater critic, *Washington Post*, provides a concise assessment of the designer's career and astute observations on his current work. The aforementioned perspectives afford the reader a solid foundation and launching point for the book's third essay where Rebecca E. Elliot, assistant curator of craft, design, & fashion, focuses on seven recent productions: *The Lost Colony*, *The Mystery of Edwin Drood*, *On the Twentieth Century*, *Grease Live!*, *The Rocky Horror Picture Show: Let's Do the Time Warp Again*, *Little Dancer*, and *Rodgers and Hammerstein's Cinderella*. These texts, combined with lavish illustrations interspersed throughout the book, elucidate the amazing creativity and skill of one of the greatest costume designers of our time.

The exhibition and accompanying publication are made possible by the generosity of Wells Fargo.

Lastly, I want to express my appreciation to William Ivey Long, for his remarkable arcs of imagination, using sumptuous fabrics and skillful construction to transform actors and delight audiences.

Dr. Kathleen V. Jameson
President & CEO, The Mint Museum

ON THE PARALLEL HISTORY OF COSTUME AND FASHION DESIGN

Annie Carlano

WILLIAM IVEY LONG's first memory of making costumes takes place the summer before first grade when he was playing in the front yard of his family's home in Manteo, North Carolina. Inspired by productions of *The Lost Colony*, he cut up a pillowcase and used the hemmed edge to fashion an Elizabethan ruff for his dog. It is easy to say that this predilection for costuming was in his DNA, having been born into a theatrical family, but that's too simplistic. The development of a thorough design process—informed by a scholar's research and an artist's imagination, nonnegotiable insistence on excellence, the ability to inspire his coworkers, and attention to details, details, details!—is at the core of William Ivey Long's enormous success. Long is driven by an insatiable curiosity and boundless energy: his formal education and many independent studies have made him one of America's leading designers of clothing and fashion for stage, film, and television (figs. 1–5).

Re-creating historic and contemporary clothing, inventing imaginary fantasy dress, and making costumes that serve the narrative of a theatrical production or performance are what costume designers do. They give life to characters, beyond spoken words, providing visual clues that convey character, station in life, and personality. To do so with authenticity, costume designers must have impeccable research skills; understanding of patternmaking, cut, construction techniques, and fabrics; and knowledge of how these elements are revealed onstage under set lighting. Costumes have a hard life; they require being made to withstand the stress of long wear, hot lights, dance movements, refittings, and alterations.

1 Maquette for embroidered organza ball gown (detail), *Rodgers and Hammerstein's Cinderella*, 2012. Photograph by Irving Solero

While the technical work of a costume designer is not so different from that of a fashion designer, the goals are different.[1] Fashion design starts with the designer's vision. Whether for couture or ready-to-wear, a fashion designer creates anew, forming trends that an anonymous client will wear.[2] Costume design starts with a script. In close collaboration with the director, a costume designer creates garments that support a collective vision for the cast of a production. Costume design has a rich and illustrious history as an integral part of the overall look and feel of plays, spectacles, and ballets.

The genre of theatrical costuming has rarely been collected by art and design museums, but instead has been relegated to specialty institutions, such as the Royal Opera House and the Theatre Museum in London. There are exceptions for costumes by highly esteemed artists: designs by Léon Bakst (1866–1924), Pavel Tchelitchew (1898–1957), Pablo Picasso (1881–1973), Giorgio di Chirico (1888–1978), and Henri Matisse (1869–1954) for the Ballets Russes can be found in several museum collections, the largest of which is the National Gallery of Australia. Yet many art and design museums, including the Mint Museum, do collect fashion, both couture and ready-to-wear.

The word *fashion*, from the Latin for *making*, first appeared in English in the sixteenth century, and referred to a "temporary" type of dress. More specifically, in 1570, the Chinese word for fashion, *shiyang*, appeared, meaning "the look of the moment." The word *costume*, by contrast, has a more generalized meaning, referencing a wide range of clothing worn by all segments of society. Costume historically signified "more stable customs related to dress."[3] The earliest museum departments of fashion and other types of clothing were named "Costume [& Textiles]" in the United States and "Dress" in the United Kingdom, with the word *fashion* replacing *costume* relatively recently, to indicate the particular type of dress featured in collections.[4] Despite the distinctions between fashion and costume, and the quibbling over hierarchy, costume design, as a part of this spectrum, has been a prestigious discipline for centuries and, as *William Ivey Long: Costume Designs 2007–2016* demonstrates, remains a vibrant aspect of visual culture today.

In casual conversations and interviews, especially with his friend and mentor the celebrated costume designer Willa Kim (1917–2016), Long has been amused by the words used to describe his profession: *artisan, craftsman, tradesman.*[5] Eschewing the word *artist*, and embracing the term *designer*, Long is remarkably self-effacing about his profession and its relative significance within the hierarchy of both the art and design worlds—which are sometimes overlapping today, if not as interconnected as they once were. It is possible that

Long, in his typically erudite manner, is bringing to mind changes to the meanings of these words, and how they have in turn changed the business of making things. The word *design* comes from the Latin *signum*, literally to "draw a sign." The word *technique*, from the Greek *techne* (*ars* in Latin, meaning art), is related to *tekton*, the Greek word for joiner or cabinetmaker. In fifteenth-century Italy, particularly Florence, where an art terminology developed, the word *disegno* referred to both the ability to make a drawing and the capacity to create a thing. A look at this early period, when the areas of art, architecture, and theatrical spectacles were closely entwined, and roles less formally defined, to the rise of the named designer in the nineteenth century, gives background to Long's chosen career and profession, as well as to his comprehensive historic approach.

During the Renaissance, this ability to create turned artists into godlike, exalted members of the community. Those who worked for the Medici court or the papacy were involved in a variety of aesthetic expressions, from architecture to painting, tapestry, and pageantry. As a graduate student in art history, Long was attracted to this historical period and the zeitgeist of Florence. Pursuing a dissertation in Renaissance wedding festivals, he began studies of Bernardo Buontalenti (1531–1608), an Italian court architect who designed costumes for theatrical performances, for celebrations of rites of passage such as weddings, and for the mostly allegorical *intermezzi*, which were elaborate entertainments with lavish dress and sets.[6] Buontalenti's costume designs of allegorical figures are sensitively rendered drawings that show details of specific patterns and fabrics. Footwear and headgear are also depicted, with annotations about materials and colors sometimes indicated.[7] In England, architect Inigo Jones (1573–1652) crafted his own costume designs for royal masques, derived from *intermezzi*, which were influenced by Jones's studies of fashion and costume in Italy, especially the drawings of Buontalenti.[8]

Striving for authenticity, sixteenth- and seventeenth-century artists and designers filled notebooks with sketches of ancient and historic dress as depicted in extant paintings and sculptures. Eventually they had access to printed sources, which made their research more efficient. Reflecting an interest in the culture of Neoplatonism, the first book of classical dress, *De re vestiaria* by Lazari Bayfius, was published in Paris in 1536.[9] This was followed, most notably, by several costume books published in Venice, such as Cesare Vecellio's extensive *De gli habiti antichi et moderni di diversi parti del mondo* (1590), which contains woodcut images and commentary on dress of the Venetians from different levels of society, as well as dress from Europe, Africa, Asia, and the Americas as worn by individuals with a presence in that international city.[10]

As the fashion center moved to France in the latter part of the seventeenth century, and court style became more lavish, King Louis XIV, as well as his flamboyant courtiers, played a role in the design of regal attire. At the pinnacle of the hierarchy, male court fashions were an opulent expression of France's growing dominance in Europe—it was the age of lace, long locks, and leather for men. The King had in-house advisors and a large wardrobe staff at his service including "a grand master, assisted by two under masters . . . a keeper of the clothes, tailoring boys, valets, wardrobe boys, washerwomen for body linen, [and] women to look after the lace."[11] The making of clothing and costume, for both men and women, as daily wear as well as for grand fetes and serious theatrical productions, were isolated activities that took place at Versailles, but the styles were disseminated throughout Paris, London, Amsterdam, and beyond by means of fashion engravings and, beginning in 1672, detailed written accounts of fashion in *Le Mercure Galant*.[12] It was also a hot topic at Paris salons led by women, who often featured updates on the latest fashions in their correspondence. Engravings of theatrical performances, illustrating costume on stage, were also produced and widely circulated. Despite the prominent playwrights and theatrical troupes in France, and the King's establishment of the Comédie Française in 1680, which often presented works by the playwright Molière, costume design had not yet emerged as a distinct profession but remained a collaborative process between artists, wardrobe specialists, and aristocrats. Actors at the Comédie Française were expected to supply their own costumes, a practice that continued into the twentieth century.[13]

Women had long been working both at court, and in Paris, sewing wardrobes, but craft and trade regulations stipulated that their work be organized through a tailor. In 1675 the *couturières* (seamstresses) were granted the freedom to make clothes for women, babies, and boys up to age eight; throughout the eighteenth century they gained even more rights.[14] The definition of the word *mode*, signifying court dress exclusively in Antoine Furetière's *Dictionnaire universel* of 1690, came to include the attire of the *beau monde*, or "high society," in the revised edition of 1701, reflecting a decade in which fashion prints were distributed more broadly, and the sphere of influence on fashion design widened.[15] During the eighteenth century, the number of people working in the fashion trades increased substantially. Entire streets and neighborhoods were occupied by embroiderers, *couturières*, tailors, glove makers, furriers, as well as *marchandes de modes*—milliners who existed as retailers, catering to the upper echelon, selling them the latest laces, trimmings, and fabrics—but whose work was not recognized as a profession until 1776. Previously it was the

2 Fabric swatches for *Prince of Broadway*, 2017. Photograph by Irving Solero

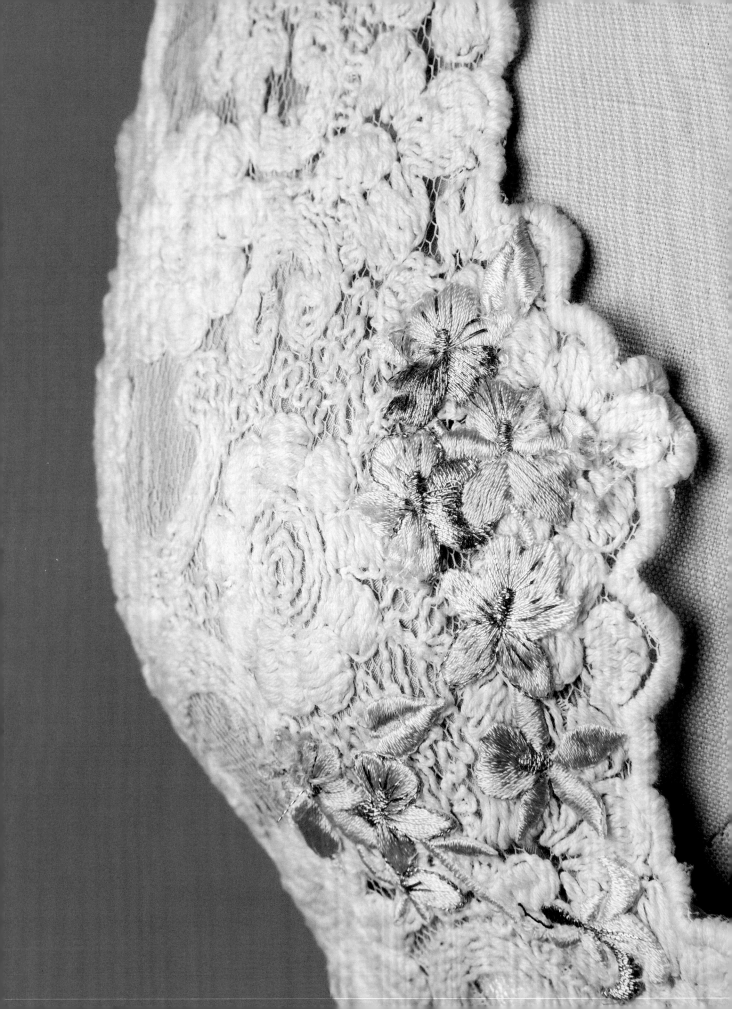

court mistresses who set fashionable dress styles for women, but Queen Marie Antoinette (1755–1793) not only set trends and revolutionized fashion, she also tampered with existing regulations and customs with regard to how clothing was made. She elevated the role of the *marchandes de modes*, and especially the main practitioner Rose Bertin (1717–1813), who among others, met with the Queen in her private chambers to discuss how to create new looks that were based more on trimmings and fabric than on cut. The advent of fashion magazines during the third quarter of the eighteenth century, illustrating the latest dress designs and published on a regular schedule, indicates how quickly styles changed and how active the fashion profession became as the industry grew. Compilations such as the *Galeries des Modes et Costumes Français, dessinés d'après nature*, published between 1778 and 1787, consisted of fine annotated images by leading draughtsmen and engravers of the day. A significant advancement in the dissemination of fashion images occurred in 1786 when the *Magasin des Modes Nouvelles Françaises et Anglaises*, the first full-fledged fashion magazine, emerged, a periodical with advertisements and literary articles.[16] Still, the engravings of fashionable dress were accompanied by mention of the draughtsmen and engravers, but not the specific designer of the fashions depicted.

Ceremonial costume at the court of Napoleon I continued to be designed by leading artists of the day, such as Jacques-Louis David (1748–1825) and Jean-Baptiste Isabey (1767–1855). They were made by the *fournisseur* (purveyor) Louis Hippolyte Leroy, who, during the first Empire, held a position one step higher than a dressmaker but not yet a designer, still working under the advisement of his patron. While these men were also designing and creating clothes for Empress Josephine (1763–1814), it is likely she too had a voice in the process, given the modern styles she wore during the First Consul. Women regained the lead in the creation of high fashion with their queens in the 1830s, with Mme Delatour making clothes for Queen Marie-Amélie (1782–1866) and, during the Second Empire, Empress Eugénie (1826–1920) had several dressmakers at court. Mlle Palmyre and Mme Vignon were among the elite dressmakers who made most of Eugénie's clothing.[17]

As the world industrialized and the upper-middle class grew in the nineteenth century, the bourgeoisie desired access to bespoke high-fashion attire to dress not as who they were but as who they wanted to become. Talented dressmakers and tailors continued to make clothing for clients, in consultation with their patrons and in examination of existing trends. But the emergence of Charles Frederick Worth (1825–1895) was a defining moment. Worth set up his

3 Costume for Jessie Mueller as Miss Janet Conover/Helena Landless (detail), "There You Are," *The Mystery of Edwin Drood*, 2012. Photograph by Irving Solero

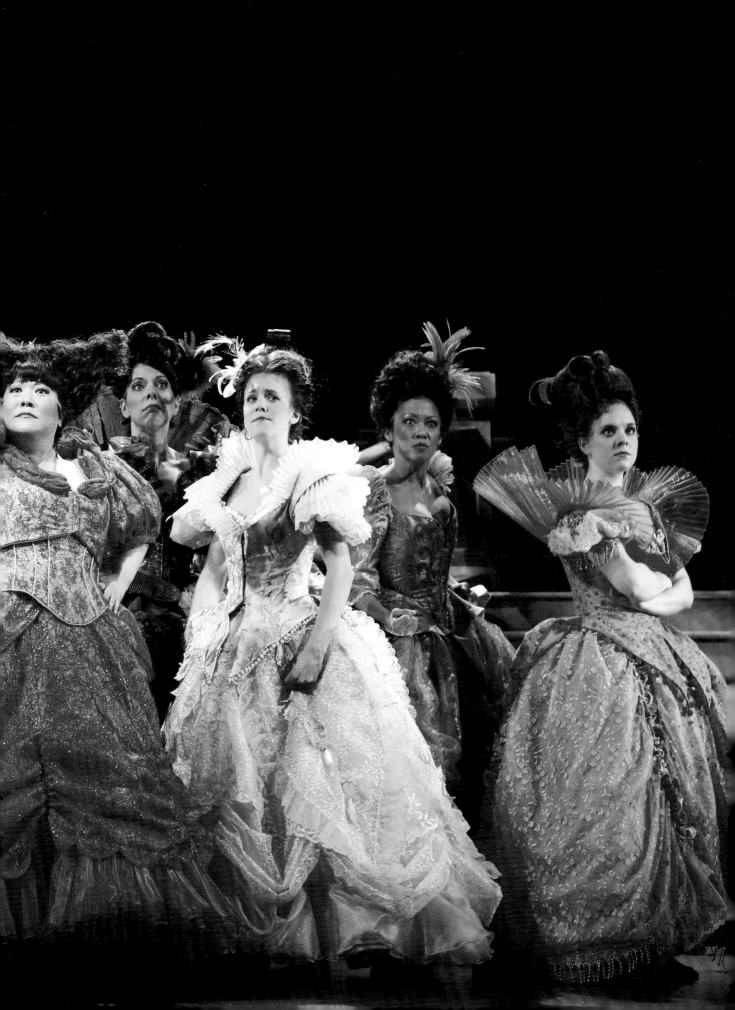

Paris shop with a business partner in 1858, and developed and promoted a new way of creating and marketing high fashion, as well as costumes for the stage. Often referred to as the "father of haute couture," his phenomenal knowledge of tailoring, fabric design, glamour, and customer service, transformed the French fashion industry. By the fourth quarter of the nineteenth century, the profession of couturier (fashion designer), as one person, whose name appeared on the petersham of the dresses, and who conceived original designs, selected fabrics, and constructed bespoke luxurious dresses, was established in Paris. This autonomy led to tremendous creativity, whether the designs were for aristocrats, or for actresses who wore these clothes both onstage and off. An 1896 issue of *Vogue* noted: "Critics at first night performances of a play give close attention to details of costume. A famous actress is famous for her dresses as well as her acting."[18]

Although couturiers were furnishing costume designs during the second half of the nineteenth century and into the twentieth, the custom of artists providing costume sketches for productions of theatrical performances persisted. Léon Baskt, Alexandre Benois (1870–1960), Georges Braque (1882–1963), Pablo Picasso, and Henri Matisse designed costumes for Sergei Diaghilev's Ballets Russes. Aesthetics took precedent over function, yielding less comfortable clothes for the stage than those of a skilled couturier versed in the craft of garment making.[19] Paul Poiret (1879–1944) an ultratalented couturier whose first successful fashion designs were worn by Réjane in *Zaza* in 1898, moved easily between the worlds of fashion, costume, and the stage. He created some of his most imaginative costume designs for his *Schéhérazade*-inspired costume party of 1911, The Thousand and Second Night.

During the first decade of the twentieth century, costume firms in Philadelphia and New York specializing in uniforms and regalia began to design for theater. Their lack of historical knowledge led producers to turn to the actors themselves to supply their own costumes. In the United States, the actors' strike of 1919 put an end to this exploitative practice, and producers were then required to provide actors with garments. Stage designers, responsible for both sets and costumes, were unionized in 1923, with costume design being recognized as a distinct genre by the unions in 1936.[20] While costume design for cinema has a shorter history, it follows the same path of development both in the United States and Europe, with producers taking the leadership role in the look of clothes, working with in-house staff and leading artists and designers to create the styles. For example, Poiret was called in to create costumes for the 1912 French film *Les amours de la reine Élisabeth* (titled *Queen Elizabeth* in the

5 Costume for Kiira Schmidt as Miss Gwendolen Pynn (detail), "There You Are," *The Mystery of Edwin Drood*, 2012. Photograph by Irving Solero

United States), starring Sarah Bernhardt.[21] Poiret's close associate, the illustrator, designer, and decorator Paul Iribe (1883–1935), as well as Erté (1892–1990), worked for Hollywood studios. Costume design was not designated as a specialized task by the American motion picture industry until 1929, when the studios established large-scale costume departments with professional staff and extensive libraries. Edith Head (1897–1981) began as a sketch artist before emerging as a leading Hollywood costume designer, and Adrian (1903–1959), also a fashion designer, was one of the other early cinematic costumer superstars. Today the fashion designer Giorgio Armani (b. 1934) has acted as a costume consultant for over two hundred films including Paul Schrader's *American Gigolo* (1980), Brian de Palma's *The Untouchables* (1987), Mick Jackson's *The Bodyguard* (1992), Christopher Nolan's *The Dark Knight* (2008), and Martin Scorsese's *The Wolf of Wall Street* (2013).[22]

If art and design museums do not collect theatrical costume design, they are beginning to recognize the artistic merit of the genre through exhibition programs such as the Mint Museum's attention in this book and accompanying exhibition. William Ivey Long honed his talent as a fashion designer while an apprentice to the great American couturier Charles James (1906–1978) from 1975 until James's death. Long has six Tony Awards earned for his distinguished career creating costumes for Broadway. He has designed historic and contemporary costumes for opera, dance, television, cinema, concerts—including the Pointer Sisters and the Rolling Stones—and extravaganzas such as Siegfried and Roy at the Mirage hotel in Las Vegas. Long's prodigious oeuvre has been acknowledged through an abundance of professional accolades and three honorary doctorates. In recognition of his meticulous adherence to traditional fashion design practices in the creation of theatrical costumes, Long received the National Arts Club's Medal of Honor for Achievement in Fashion in 2015 (fig. 6). William Ivey Long takes his place in the pantheon of great costume designers from Bernardo Buontalenti to Willa Kim.

6 The National Arts Club medal awarded to William Ivey Long on April 13, 2015

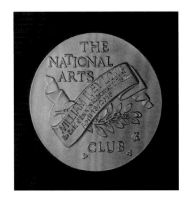

NOTES

1. William Ivey Long's design process is discussed by Rebecca Elliot in her essay "The Art and Craft of William Ivey Long 2007–2016," in this volume.

2. Couture is defined in this essay, as it is commonly used, to describe the highest quality bespoke fashions, created by couturiers or fashion designers, that are made to measure for individual clients who have personalized fittings. The legal definitions of couture, haute couture, prêt-à-porter, and *créateurs de mode* are strictly regulated by La Fédération Française de la Couture du Prêt-à-Porter des Couturiers et des Créateurs de Mode trade association or Chambres Syndicales.

3. Ulinka Rublack, "Renaissance Fashion: The Birth of Power Dressing," *History Today* 61, no. 1 (January 2011), accessed January 30, 2017, http://www.historytoday.com/ulinka-rublack/renaissance-fashion-birth-power-dressing.

4. For example, American art museums that recently replaced the word *costume* with the word *fashion* include the Textile and Fashion Arts department, Museum of Fine Arts, Boston; Fashion department, Phoenix Art Museum; and Craft, Design, & Fashion department, the Mint Museum; in London, the Victoria & Albert Museum changed the department title from Textiles & Dress to Textiles & Fashion; and Zandra Rhodes opened the Fashion and Textile Museum; in Paris, the Musée de la Mode is the national fashion museum, but the city's Musée de la Mode et du Costume is so named to indicate the larger breadth of those collections.

5. William Ivey Long, conversation with author, January 13, 2017; "Working in the Theatre: Costumes," YouTube video, 33:02, posted by American Theatre Wing, January 28, 2015, https://www.youtube.com/watch?v=-xZglYQSJ3Q.

6. Long's doctoral studies were interrupted by the departure of his thesis advisor from the University of North Carolina at Chapel Hill. This led ultimately to his decision to study set design at the Yale School of Drama.

7. At the time, it was customary for the costume designer to provide a pen-and-ink and wash drawing only. Assistants would fill in color and other details before the drawing went to the tailor. Diana de Marly, "Four Costumes by Stefano della Bella," *Costume: The Journal of the Costume Society* 12, no. 1 (1978): 52.

8. Maarit Uusitalo, "Inigo Jones Costume Design and Symbols in a Stage Costume in Late Renaissance Court Masque" (master's thesis, Aalto University, 2012), 18, https://aaltodoc.aalto.fi/bitstream/handle/123456789/6307/optika_id_732_uusitalo_maarit_2012.pdf?seq.

9. Edward Maeder, "The Celluloid Image: Historical Dress in Film," in Edward Maeder, ed. *Hollywood and History: Costume Design in Film* (London and Los Angeles: Thames and Hudson Ltd. and Los Angeles County Museum of Art, 1990), 41–42.

10. Cesare Vecellio, *De gli habiti antichi et moderni di diversi parti del mondo* (Venice: Damiano Zenaro, 1590); Cesare Vecellio, *Habiti antichi et moderni di tutto il mondo* (Venice: Appresso I Sessa, 1598).

11. Madeleine Delpierre, *Dress in France in the Eighteenth Century*, trans. Caroline Beamish (New Haven and London: Yale University Press, 1997), 103.

12. Elizabeth Davis, "Habit de qualité: Seventeenth-Century French Fashion Prints as Sources for Dress History," *Dress: The Journal of the Costume Society of America* 40, no. 2 (2014): 123–31.

13. *The Comédie-Française Registers Project,* accessed January 30, 2017, Cfregisters.org.

14. Delpierre, *Dress in France in the Eighteenth Century*, 131.

15. Davis, "Habit de qualité," 138–39.

16. Delpierre, *Dress in France in the Eighteenth Century*, 144–45.

17. Diana de Marly, *The History of Haute Couture 1850–1950* (New York: Holmes & Meier Publishers, Inc., 1980), 14.

18. Quoted in Amy de la Haye and Valerie D. Mendes, *The House of Worth: Portrait of an Archive* (London: V & A Publishing, 2014), 125–26.

19. For example, Eugenia Lipkowska, who danced with Serge Lifar in a production of Diaghilev's *Le Bal*, in 1929, commented, "this dance was destroyed by the heavy costumes. Chirico's dresses were undoubtedly the most striking part of the ballet, being covered with architectural elements and simulated parchment scrolls to give the impression that they were made of paper or plaster, but their weight and stiffness made them hard to dance in." Quoted in Marianne T. Carlano, "Four Ballet Costumes Designed by Giorgio de Chirico: Art and Architecture in Motion," in *Art News*, October 1984, 127.

20. Whitney Blausen, "Costume Designer," accessed January 30, 2017, http://fashion-history.lovetoknow.com/fashion-clothing-industry/costume-designer.

21. The costumes for *Les amours de la reine Élisabeth* (1912) appear to be a mélange of the fashions of late sixteenth-century England and 1912 Paris. Six episodes of the film can be seen on YouTube, starting with "1/6: 1912 Queen Elizabeth (Sara Bernhardt, Max Maxudian, Lou Tellegen)," 8:01, posted by AVisitToThePast, May 12, 2013, https://www.youtube.com/watch?v=OE33P3zfgPY;ZhSv6quOTRI;Nj2-3RkvzXE. Mixing contemporary styles with those of the past is a common pitfall of costume designs for historic dress, but period costumes by William Ivey Long are consistently accurate in their silhouettes.

22. Mr. Armani was not the official costume designer for the film but Richard Gere's character is expressed through the Armani suits he wears.

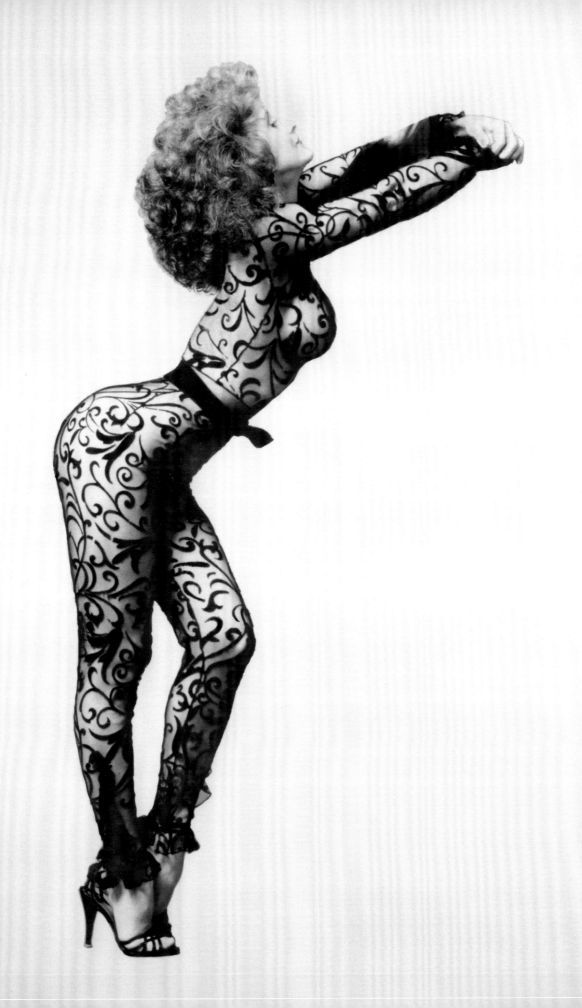

THE GENIUS OF WILLIAM IVEY LONG

Peter Marks

BETWEEN A BROADWAY COSTUME DESIGNER AND A STAR, it isn't always fashion, fun, and games. Consider the brush fire that had to be quelled in 2008, after William Ivey Long—in his trademark genteel way, redolent of Southern wit and courtliness—presented to Stockard Channing one of the dresses for her to wear in a major revival of Richard Rodgers and Lorenz Hart's classic musical *Pal Joey*.

In the workshop of a New York costume fabricator, Long showed Channing a dress, made in an intricately beaded, form-fitting, brown and gray brocade, that the actress instantly took a dislike to. The fabric struck her as a little bulky. And one can easily imagine how that particular attribute might not be a Broadway actress's favorite.

"I stood there and I said, 'William, there's a lot going on here,'" she recalls. "I'm getting more and more nervous. I finally turned to him and said, 'William, it looks like tree bark!'"[1]

What followed was a tense scene neither of them, over the course of a thirty-year friendship, had ever experienced before, an encounter that says something about the high-stakes crosscurrents that go on in a Broadway fitting room. A designer eager to please, proud of his work, and mindful of deadlines and budget, and a star wanting to look her best, desiring not to be difficult, but still certain of what works for her body, both struggling to negotiate sensitive terrain. In such moments do the demands and pressures of costume design reveal themselves, when a designer must calculate the cost-benefit ratio and understand that it is the actress who must go out there on stage in the garment—and feel good wearing it.

7 Anita Morris (Carla), "A Call from the Vatican," *Nine*, 1982. Photograph by Kenn Duncan, © Billy Rose Theatre Division, The New York Public Library for the Performing Arts

It was then and there that Channing had all her confidence in, and admiration for, Long confirmed. After a little more steam was blown off, and the designer took the dress into his hands to consider how it could be made to look less heavy, Channing left the studio. And when she did, she says, she turned around to a sight that touched her. "He's looking at the dress," she remembers, "and picking out sequins, one by one."

The story was William Ivey Long to a "T." The dress, in his careful reconstruction, ultimately proved a triumph. His response to the mini-crisis was the compassionate—and eminently practical—action of a man who, as much as any other theater artist present or past, ticks off all the boxes for what it means to be a Broadway designer of taste, inspiration, and diplomacy. A craftsman of prodigious style and endurance, Long has been behaving in this manner on the Great White Way and beyond for over forty years; his resume runs to more than seventy Broadway productions, for which he's collected an astonishing six Tony Awards, out of a total of fifteen nominations (fig. 8).

Even a cursory perusal of the list of shows for which the North Carolina-born Long made the costumes reveals his extraordinary impact: his designs graced the original productions of such musicals as *Nine* (1982), *Smokey Joe's Cafe* (1995), *Contact* (2000), *The Producers* (2001), *Hairspray* (2002), *The Boy from Oz* (2003), and *Grey Gardens* (2006); seminal revivals of *Guys and Dolls* (1992), *Chicago* (1996), *Cabaret* (1998/2014), *La Cage aux Folles* (2004), *Rodgers and Hammerstein's Cinderella* (2013), and *On the Twentieth Century* (2015); and plays by dramatists ranging from Terrence McNally and Neil Simon to Bertolt Brecht, Arthur Miller, and Tennessee Williams.

Beyond the legitimate stage, he's dressed such fashionista one of a kinds as Joan Rivers, Mick Jagger, and Siegfried and Roy; put young actors in tight T-shirts and sweaters for television's *Grease Live!* (2016); outfitted Twyla Tharp's company to dance to Mozart; and placed Renée Fleming in belle époque gowns in *The Merry Widow* at the Metropolitan Opera. His work can't be categorized as highbrow or lowbrow; it's everybrow. He's designed for Leonard Bernstein at the Vienna State Opera, as well as the Pointer Sisters at Caesars Palace.

In entertainment circles, his name is synonymous with both a bravura theatricality and a dazzling sultriness, especially as these notions pertain to an ideal draping of the female form. If you think back to any of the indelible silhouettes that have sprung from his mind—Anita Morris's eye-popping body stocking in *Nine* (fig. 7); the negligees for the cell mates in the blockbuster revival of *Chicago*; the eponymous dress for *Contact*'s Girl in the Yellow Dress (fig. 9); even Harvey Fierstein's getups for *Hairspray* (fig. 10)—you're made aware of Long's reverence for showing off bodies to their best advantage.

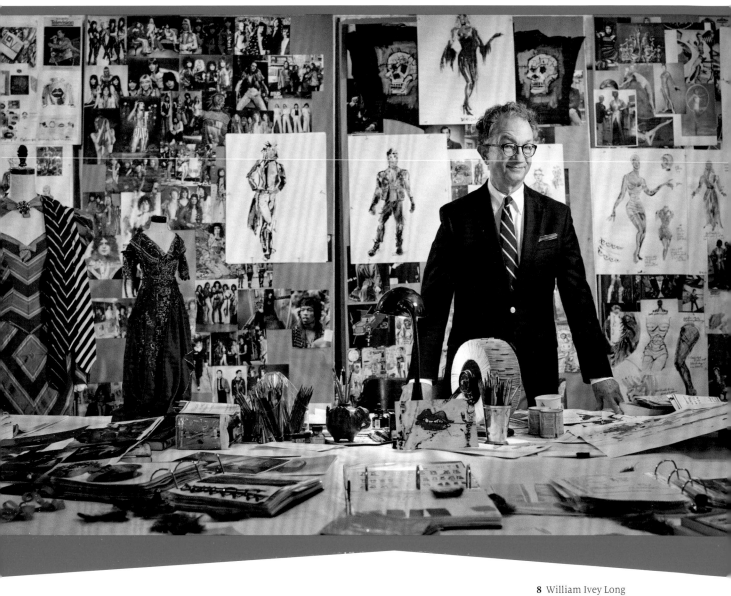

8 William Ivey Long in his studio with inspiration boards for *The Rocky Horror Picture Show: Let's Do the Time Warp Again* (2016), along with a costume from *Curtains* (2007), and a maquette for *The Merry Widow* (2014), 2016. Photograph by Jonathan Becker for *Vanity Fair*

9 Colleen Dunn (Girl in the Yellow Dress) and Alan Campbell (Joe), *Contact*, 2002. Photograph by Paul Kolnik

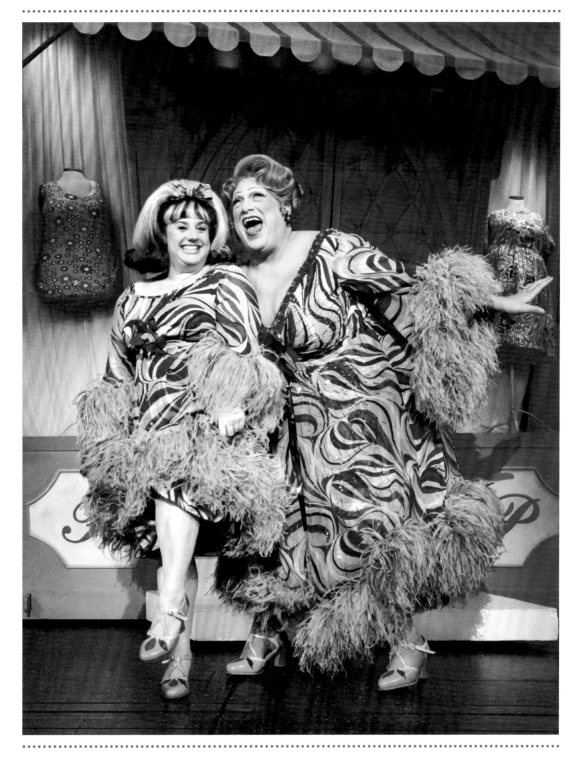

10 Marissa Jaret Winokur (Tracy Turnblad) and Harvey Fierstein (Edna Turnblad), "Welcome to the '60s," *Hairspray*, 2002. Photograph by Paul Kolnik

"William takes people and makes them beautiful in ways that they never dreamed of," says playwright, screenwriter, and essayist Paul Rudnick, a decades-long close friend. "He has a style that adapts to a wide range of productions, but he also has a signature so that people realize, 'Oh, I'm at a William Ivey Long show.' That's rare, to have a recognized style, one that also has actresses saying, 'Oh my God, look how fabulous I look!' I've seen him do that so many times."[2]

The art of dressing up has been around essentially since the dawn of theater: masks and costumes were used in the plays of the Greek dramatist Aristophanes, for example, to represent animals and other aspects of nature. In Shakespeare's time, actors are said to have scavenged from their own wardrobes, or accessorized with armor left over from previous productions. Later on, the great ladies of eighteenth- and nineteenth-century theater in London were expected to make stage entrances in their own lavish gowns—even if they were playing the lowliest of servants.

The role of the theatrical costume designer came into its own in the twentieth century and along with it the idea of clothing as an integral part of a production's aesthetic, as well as other visual elements including scenery and lighting. Costumes were integrated into the artistic whole with more emphasis on how they could help to define character and tell the story. That mandate invited into the theater world a cadre of visionary designers who, like their counterparts in movies, became trademark industry names, people such as Cecil Beaton, Irene Sharaff, Florence Klotz, Theoni V. Aldredge, and Willa Kim. Their designs helped set the conversation for the works they decorated: think, for example, of the feathered hats and soigné gowns and cutaways Beaton devised for the legendary black-and-white "Ascot Gavotte" scene in *My Fair Lady*. Such masterstrokes can brand a musical almost as indelibly as its score.

Long came of age in the next wave of great Broadway costume designers, emerging just after Jane Greenwood and Ann Roth, and in tandem with Santo Loquasto, Bob Crowley, and Susan Hilferty. By the time of his first Tony Award in 1982—at the age of thirty-five for Maury Yeston and Mario Fratti's *Nine*, a musical adaptation of Federico Fellini's film *8½*—he had established himself as one of the most original, in demand, and hardworking members among his coterie in New York.

His costumes for that show, the story of the women in the life of an unfaithful Italian film director, constituted a fantasia of showgirl and Mediterranean chic. The sheer, black lace body stocking worn by Morris, playing the director's mistress, for her gymnastic number, "A Call from the Vatican,"

remains one of the most celebrated sartorial achievements in Broadway history. As she sings, she performs a dance that Frank Rich described in the *New York Times* as a "one-body simulation of two-body copulation."[3] Her costume was a strategically patterned illusion of nudity; combined with the choreography of Tommy Tune, the effect enhanced the number's Italianate sexiness, without treading anywhere near vulgarity.

"My job is to interpret the world, the dreams of the playwright," Long says on a winter morning in his studio in Manhattan's Tribeca neighborhood, a bustling duplex he's maintained for decades, where his longtime vice president and majordomo, Brian Mear, oversees the day-to-day operations.[4] While gold records might bedeck the walls of a musician's lair, Long's greatest hits adorn mannequins around the studio: in a prominent place, in fact, is one of Morris's body stockings (several had to be made, of course, because of the eight-shows-a-week workout the costume received).

"Something about that costume transcended theater," observes Emilio Sosa, a fellow designer who created the costumes on Broadway for *Motown: The Musical* (2016) and Gloria and Emilio Estefan's jukebox musical, *On Your Feet!* (2015), and was also twice the first runner-up on television's fashion competition reality show, *Project Runway*.[5]

Sosa was sixteen in 1982 when he saw Morris in the costume, and it isn't too much to say that it changed his life. "I was like a puppy dog, how much that costume spoke to me. Anita Morris was the most beautiful canvas you could work on, and it was the right costume, on the right girl, in the right show."

"It wasn't just a leotard, it was a beautifully constructed garment," Sosa adds, explaining that the embellishments Long thought to include contributed to the sensation of a complete artistic statement. "He added a ruffle at the bottom of the leg, not just to have the eye stop at the ankle, but to finish it off." (Of Long's designs for *Nine*, Rich, in his *New York Times* review, used the adjective: "spectacular.")[6]

How a designer develops that kind of eye remains eternally elusive. Long, a lover of scholarship and a deep believer in research before beginning a project, professes himself to remain in awe of how great artists apply their imaginations to the physical world. "Manet—or was it Monet?—said, 'I wish I didn't know what I was looking at, so that I could paint what I see,'" the designer says, flipping through one of the library of art books on his shelves (fig. 11). They are resources he consults to come up with his own color palettes and design concepts.

In an encounter with Long, one's first impression is not of a dandified esthete in a stuffy atelier, but of an energized worker bee, buzzing merrily

through his day. His own signature uniform, going back to his academic years, is less out of the pages of *Vogue* than *The Official Preppy Handbook*: khaki pants, starched white shirt, navy blazer, repp tie. It's as devoid of flamboyance as a window display at Brooks Brothers, and it's a reflection of a philosophy he's stuck to, that the person in the room who should stand out is the client. "I'm very happy being No. 2," he confides, by which he means that he works best in healthy and supportive collaboration.

"I remember the first time I ever met him," Rudnick says. "I was an undergraduate drama major at Yale, and he was in the graduate school. One summer, he made the huge mistake of hiring me as his assistant at the Yale Cabaret"—a night spot run by students at the Yale School of Drama. "I had no skills; I could try to cut some fabric into squares and I would ruin one hundred yards of silk chiffon. But William, on zero money, would come up with costumes every day, on pure genius." Long grew up on a remote fringe of the theater world, in the Carolinas, never envisioning for himself a life among corsets, bustiers, and boas. His mother, Mary, was an actress and high school drama teacher, and his father, William, was the founder of the department of dramatic arts at Winthrop University in Rock Hill, South Carolina, the town where Long spent his formative years. "My parents met as play makers and became academic theater people," Long says. His father, the eleventh child in a longtime tobacco-growing family in Seaboard, North Carolina, on the Virginia border, had been the beneficiary of a four-year play writing scholarship to the University of North Carolina at Chapel Hill. But it was his namesake who would scale the heights of the professional theater.

Not that the ladder was always planted in the logical spot; the young William was first drawn to architecture, not fashion. "As a child, I built little villages outside, among the tree roots," he recalls. He designed sets for his father's productions at Winthrop, and he spent summers with his parents and his sister and brother on North Carolina's Roanoke Island. There, they were involved in *The Lost Colony*, the annual epic outdoor drama, a pageant founded in 1937 that still draws hordes of tourists today. The inspiration was the centuries-old mystery surrounding the English colony founded on the island in 1587, only to vanish without a trace within three years. English ships arriving with supplies found no surviving colonists.

At twelve, Long was the prop master for *The Lost Colony*; by eighteen, he was its technical director. Along the way, he cultivated an interest in art, sketching animals and objects in charcoal. While continuing to work summers on Roanoke Island—Long remains a major force in the production to

this day—he attended the College of William and Mary, majoring in French history. Contemplating a life as an author, he entered the doctoral program at the University of North Carolina at Chapel Hill to study Renaissance art and architecture.

And still, the theater beckoned.

It was a friend, Betty Smith, author of the novel *A Tree Grows in Brooklyn* and a writing professor at Chapel Hill, who set him on his eventual path. According to Long, having participated in *The Lost Colony* and seen some of his work, she asked him, "What are you doing with your talent?" At her urging, he applied to the Yale School of Drama to study set design. Despite their love of theater, his family didn't welcome the news. "That was a big move for him in terms of defying expectations," Rudnick says. "His parents were not instantly supportive, so William had to make his own way." Through connections with theater people in Chapel Hill, Long secured recommendations from influential practitioners, like Broadway director and choreographer Joe Layton, and after submitting some sketches, he was admitted.

Yale didn't offer a degree for costuming; Long earned his degree in set design, studying with widely admired Broadway set designer Ming Cho Lee, probably best known for his association with Joseph Papp at Off Broadway's Public Theater. But devising costumes for the Yale Cabaret, alongside budding performers and writers at the time like Sigourney Weaver and Christopher Durang, gave him a chance to fall in love with the inventiveness, whimsy, and discipline of costume design. (Playwright Wendy Wasserstein, another Yale student at the time, became a lifelong friend, too.) He found that costumes were a good fit for him, in part, because of the strong intellectual dimension to the work.

"Most designers do acres of research, and William is such a natural historian," Rudnick says, adding that an attention to detail became a hallmark. "If an actor went on stage carrying a briefcase, William would make sure it was filled with appropriate items—wallets, handkerchiefs. It's always been a master class in how to make an actor comfortable." Rudnick experienced this firsthand with the productions of his own plays, on which Long has often worked. One of Long's early assignments was Rudnick's professional debut as a playwright: *Poor Little Lambs*, a 1982 Off-Broadway comedy about the Yale a capella singing group the Whiffenpoofs.

The designer, it seems, had the ability to make actors feel at ease in the most extreme of circumstances. "It had an amazing cast," Rudnick recalls. "At one point, they are all singing in drag. William put the young Kevin Bacon in a peach chiffon tea dress."

After graduating from Yale in 1975, he moved to the bohemian Chelsea Hotel on West Twenty-Third Street in Manhattan—and basically starved. "'I was so scared that I would eat one banana and one yogurt a day, and I weighed 135 pounds,'" Long told the *New York Times*'s Alex Witchel in 2006. "'I can only imagine now that here was this scarecrow person, lacking the kick and drive and the clawing that I have shown is the center of my work ethic ever since.'"[7]

The work, for low or no pay, came slowly at first; he supported himself, Witchel reported, designing dolls that friends sold for him. His fortunes changed with his first break, a revival in 1978 of Nikolai Gogol's *The Inspector General* at Circle in the Square in New York. The reviews weren't glowing, but the assignment put him on the map. As luck would have it, he would soon follow that up with the transfer of a production he designed at Yale, *The 1940's Radio Hour*, a play with incidental music, that made an interim stop at Washington D.C.'s Arena Stage before moving to Broadway in the fall of 1979.

Channing met Long in the early 1980s on another Off-Broadway play, Michael Cristofer's *The Lady and the Clarinet*, about a woman ruminating on the big love affairs of her life that failed, as she waits for a new date to pick her up. The play was not well received but it cemented a bond between Long and Channing, one of the many actors with whom he'd forge close relationships. In that production, Long helped her with a challenging physical transformation, of playing a woman at various ages from fifteen to mature adult.

There would develop a level of trust between them that has endured for decades. "I knew that William would never let me go out onstage looking anything but my best," she says. They'd go on to work together on one of Channing's biggest New York triumphs, the role of Ouisa in John Guare's urbane 1990 comedy-drama *Six Degrees of Separation*.

If the Tony-winning costumes for *Nine* would give his career a new momentum, he seemed to have the metabolism to sustain it. Long's eyebrow-raising work ethic—perhaps informed by those early years of penury—meant he would juggle any number of assignments. Though he employs a small staff to assist with the clerical details and logistics, every costume is drawn by him. The pace can be stunning. Between March 1988 and May 1989, for instance, he completed an astonishing fifteen design projects: four plays, four musicals, a teleplay, and six dance pieces.

The process for Long begins with his inspiration board: a blank white panel standing about seven feet high in the basement of his studio. Onto the board, he will tape or staple a veritable montage of colored paper scraps, photographs, Xeroxes of landscapes and portrait paintings, and fabric swatches. These bits

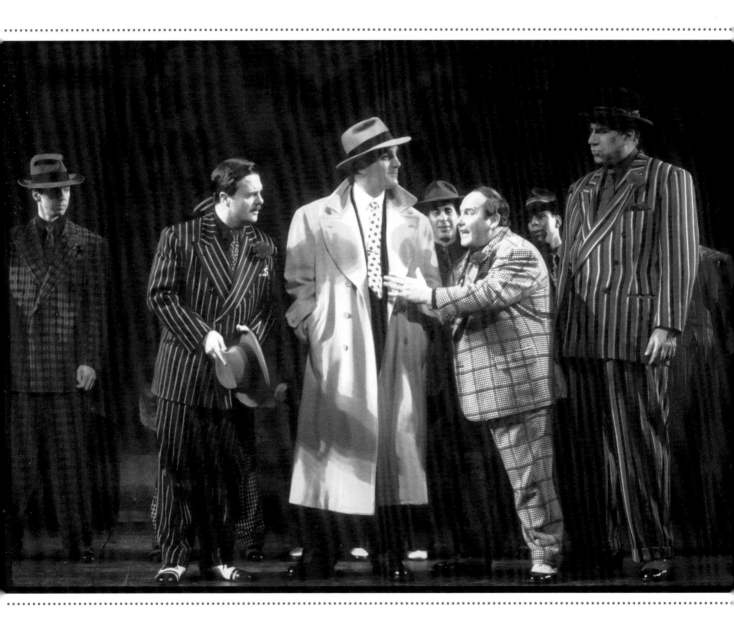

are gleaned from his massive archives; his curatorial instincts are so ingrained that he bought an abandoned, 14,500-square-foot schoolhouse in Chester, Massachusetts, to store the overflow of fabrics and costumes.

Out of the scraps on the inspiration board Long assembles a kind of free-form mosaic that will become the look of a production.

"Nothing replaces books that you thumb through," Long says, retrieving a volume of the paintings of Paul Gauguin from a shelf to give a short demonstration of how inspiration can work. For the landmark 1992 revival of *Guys and Dolls*—a production that made Broadway stars of Nathan Lane and Faith Prince and gave voice to a love for the city of New York at a time when it was ailing financially—he teamed with set designer Tony Walton to give the show its exuberant Damon Runyonesque look (fig. 12).

"Tony's sets were so colorful that he didn't leave any colors for me!" Long explains, only half jokingly. To come up with his own color scheme for the show, he happened upon an unusual method. "I took the book and turned it upside down," he says, demonstrating the technique for me at his table. The flipped pages, with their South Sea paintings in saturated crimsons and violets, revealed shadings and hues to which the eye normally isn't drawn. "Gauguin was my spirit guide," he declares. "Each one of Tony's sets I matched to a painting."

This painterly inclination conforms to other aspects of Long's technique; his first thumbnail renderings of costumes are painted in watercolor—vibrant, radiantly filled with personality.

"It's about a palette, like any great artist," says Natasha Katz, the renowned lighting designer. The winner herself of six Tonys, Katz met Long when she was the assistant lighting designer on *Nine* and notes in Long's work a visceral understanding of how an audience looks at what's on the stage. "He knows how to make the primary character so important that they pop out from the background." She thinks it's an instinct, knowing how a silhouette, under light, "whether a costume is cinched at the waist or a muumuu," communicates the essence of character.

"Arthur Laurents wrote it in *Gypsy*," Katz says, referring to that musical's librettist. "'Either you got it, or you ain't.' And boy, he's got it."[8]

··················

Bundled up against the cold on a frigid day in early January 2017, Long leaves the studio with vice president and longtime associate Donald Sanders and bags filled with drawings and swatches. They board a subway for the ten-minute commute to the garment district and the studio of John Schneeman, one of the

12 Nathan Lane (Nathan Detroit), Steve Ryan (Lt. Brannigan), Ernie Sabella (Harry the Horse), and Herschel Sparber (Big Jule), "The Oldest Established," *Guys and Dolls*, 1992. Photograph by Martha Swope, © Billy Rose Theatre Division, The New York Public Library for the Performing Arts

variety of artisans whose workshops transform Long's brainstorms from one dimension into three.

The neighborhood is awash in costuming craftsmen: shoemakers, wig makers, tailors, dressmakers, milliners, jewelry makers. There are even whole shops devoted to the specialty-sewing task of pleating. In Schneeman's small studio, two seamstresses sit at sewing machines, painstakingly finishing jackets and skirts for various projects. As each piece is finished, an assistant brings it to Schneeman for inspection—and for a beguiling ritual. It looks initially as if he is giving each garment a sniff. Actually, he's pressing his lips to the pieces—giving them a kiss.

"I kiss them goodbye," Schneeman says.[9] The hope being, in such a demanding and deadline-crazed business, that he never sees—i.e., has to fix—them again.

Long and Schneeman have known each other for years, and the studio conversation reflects the shorthand vocabulary, and, on occasion, the cheekiness, that mutually respected professionalism engenders. Fashion, fabric, and fabricating terminology is unrolled in an endless spool: "double georgette," "crepe de chine," "bouclé."

The designer is here for a crucial phase in costuming, to pick out the dozens of fabrics that will go into the final wardrobing of a cast. In this case, Long is dressing dancers in the company of choreographer Paul Taylor, for whom he has been making costumes since 1983. The company is unveiling a new piece, *The Open Door*, choreographed to composer Edward Elgar's *Enigma Variations* (figs. 13–15). And its world premiere in Providence, Rhode Island, is in—gulp—less than a month.

Sanders places photographs of each of the dancers on a table in front of Long and Schneeman, along with drawings of the elaborate period costumes—swallowtail coats, artists' smocks, ruffled skirts—as well as bundles of fabric samples. Since the eleven dancers are due in the studio the following week for fittings, the choices have to be made quickly; in some cases, one costume requires as many as a dozen different materials.

And it's not only colors and patterns that have to be decided on. Practicality is as important as the appeal to the eye.

"Maybe polyester collars? These have to tour," Long says to Schneeman, as he gives a swatch the once-over. "You have to think about living in all of this."

"They have to be silk," Schneeman says at another point, "because nothing else really dances."

The businesslike conversation yields funny and fascinating tidbits about the nature of the work. One of the dancers, playing a comic character, will be

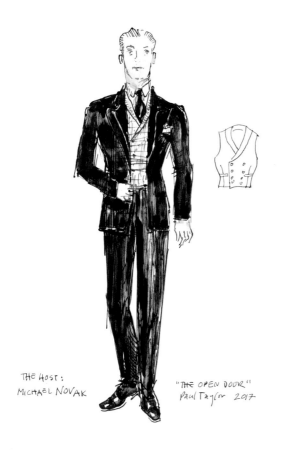

THE HOST:
MICHAEL NOVAK

"THE OPEN DOOR"
Paul Taylor 2017

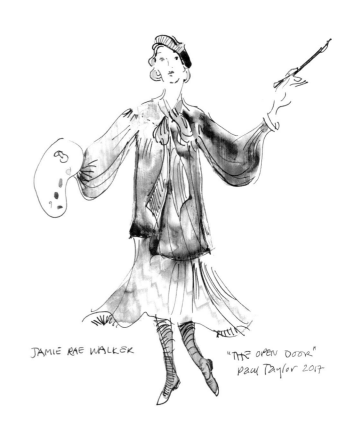

JAMIE RAE WALKER

"THE OPEN DOOR"
Paul Taylor 2017

CLOCKWISE FROM
UPPER LEFT
13 Sketch for Michael
Novak, *The Open Door*,
Paul Taylor Dance
Company, 2017. Ink,
gouache, and watercolor
on Bristol board

14 Sketch for Jamie
Rae Walker, *The Open
Door*, Paul Taylor Dance
Company, 2017. Ink,
gouache, and watercolor
on Bristol board

15 Sketch for Heather
McGinley, *The Open
Door*, Paul Taylor Dance
Company, 2017. Ink,
gouache, and watercolor
on Bristol board

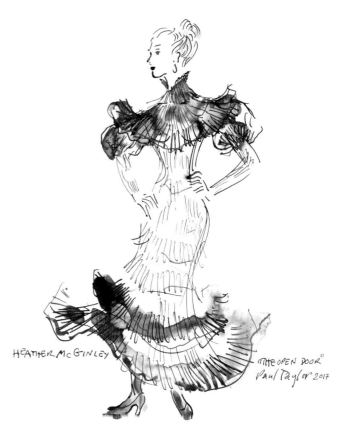

HEATHER McGINLEY

"THE OPEN DOOR"
Paul Taylor 2017

in mismatched pants and jacket and vest. Long mentions that polka dots are a good choice because "polka dots are the international sign for comedy." There's talk, too, about how the extreme exertion of Taylor's dancers affects the clothes they wear—particularly as they sweat through costumes that ordinarily can't be dry cleaned after every performance. The solution? Spraying the garments with vodka.

"Vodka kills the bacteria," Schneeman says.

The session takes about an hour and a half. From time to time, the men carry pieces of fabric into a separate room, illuminated to simulate stage conditions, to see how a color will look under the hot lights. By the time it's over, Schneeman's studio will have—literally—its work cut out for it. And hopefully, within two weeks, with yards of material purchased and seams sewn, he'll be able to kiss the costumes successfully goodbye.

...................

To understand the dynamism of Long's footprint in the theater, you have to consider both the body and the soul. "He distills clothes down to the essence," says set designer Beowulf Boritt, who's worked on five shows with Long. "The silhouette always so perfectly defines the character. With some designers, the clothes wear the people. With William, it's always the people wearing the clothes."[10]

That observation is borne out, time and again. Case in point: the way Long sartorially channeled Mel Brooks, the king of zany, for the 2001 juggernaut show *The Producers*. The musical, about hilariously conniving Broadway producers, gave Long many opportunities to exercise his funny bone, with perhaps none funnier than the statuesque drag outfit he concocted for Gary Beach, whose portrayal of risibly clueless stage director Roger De Bris earned him a Tony (fig. 16). The art deco sequined gown, worn with long white gloves, weighing forty pounds and costing twenty thousand dollars, is the first glimpse an audience gets of De Bris; it's his costume for a party, and its model is, of all things, the Chrysler Building—complete with crown.

The danger, of course, was just what Boritt outlines, a costume upstaging its wearer. But the character of De Bris is so outrageous, and Beach was so gloriously histrionic in the role, that going over-the-top was the only logical way for a costume designer to proceed.

"A model, they're paid to wear clothing," says his fellow designer Sosa. "An actor, you're helping to develop a character. And that's about more than what they are wearing. It's about crafting a three-dimensional person onstage."

Long did attempt a commercial foray onto Seventh Avenue in the 1980s, but the business fizzled. His eye for contemporary fashion was confirmed, though,

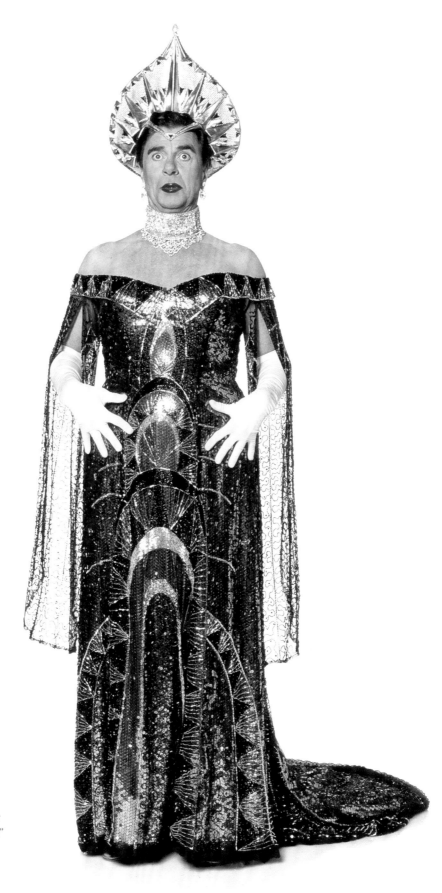

16 Gary Beach (Roger De Bris), "Keep It Gay," *The Producers*, 2001. Photograph by Paul Kolnik

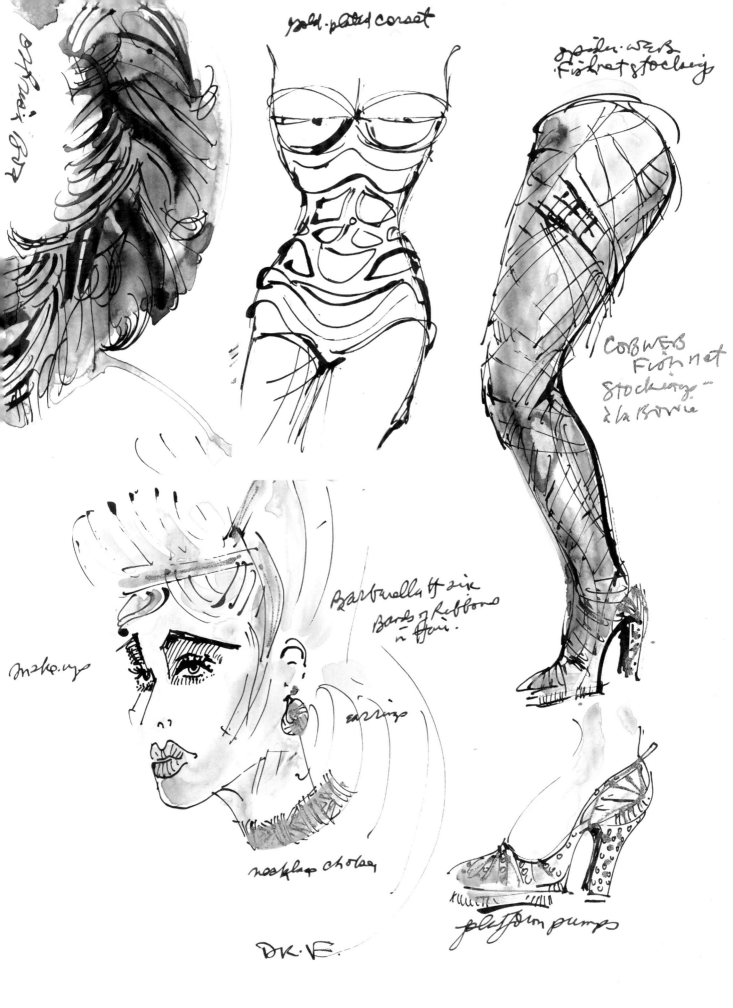

gold-plated corset

spider-web
fishnet stockings

offset wig

COBWEB
Fish net
Stockings
à la Bowie

Barbarella Hair
Bands of Ribbons
in Hair.

earrings

make-up

necklace choker

DK. F.

platform pumps

17 Sketch of costume
details for Laverne Cox
as Dr. Frank N. Furter,
*The Rocky Horror
Picture Show: Let's Do
the Time Warp Again*,
2016. Ink, gouache,
and watercolor on
Bristol board

18 Sketch for lips
pattern for Columbia's
pajamas, *The Rocky
Horror Picture Show: Let's
Do the Time Warp Again*,
2016. Ink, gouache, and
watercolor on Bristol
board

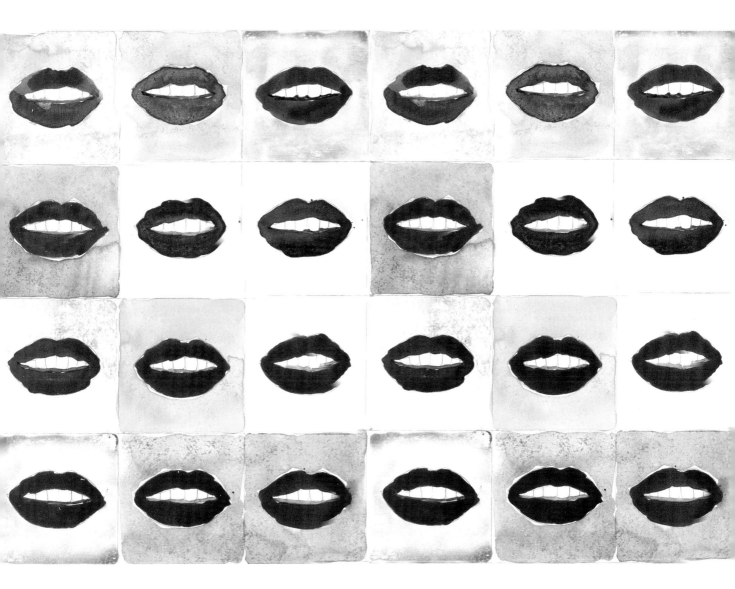

a few years before *The Producers*, when he showed a whole other aspect of his skill set with the sleek, darkly seductive outfits he dreamed up for *Chicago*. The musical opened in 1996 and, in its continuous and ongoing run, has had his designs on display ever since—the equivalent, if you will, of more than 8,400 runway shows.

So alluring are the timeless, black silhouettes that the costumes have become the musical's global signature; they taught Broadway a new manner of image making. Witness the advertising campaign that has run for twenty-one years: the faces of the actors may change, but those outfits, and their chic intimation of hanky-panky, never do.

It's important to note, too, that mood, style, and character are not the only considerations. Broadway costumes must be functional. And sometimes, function dictates everything else. Long faced this challenge head-on in the 2013 production of *Cinderella*, based on Rodgers and Hammerstein's television movie of the 1950s. A quicker change than the magical conversion of Cinderella's rags into her ball gown would be tough to conjure. The moment in which the downtrodden heroine becomes a glamour girl requires masterly conjuring.

To trick the audience's eyes, Long built a trick dress, an effect he felt comfortable constructing, thanks in part to his experience with the illusion-minded Siegfried and Roy at the Mirage hotel in Las Vegas back in the 1990s. Laura Osnes, who played Cinderella, executed a movement toward stage right as she spun that allowed her to retrieve a piece of the costume as it unfurled into a billowy gown: when the feat was perfected, it did indeed look as if a magic wand had been waved.

The counterweight to technical proficiency for a great Broadway costume designer has to be a human touch. This ineffable attribute is the one that everyone who's worked with Long seems to mention. Yes, of course, there's a prickly side to his personality; he can be provoked, even be a bit assertive. But friends say he's had to fight hard to earn the seat at the creative table for designers, who sometimes are cast by directors and producers in merely supportive roles. He proudly notes, for instance, that in assuming the leadership of the American Theatre Wing in 2012 as chairman—a position he relinquished only in 2016— he was the first working designer ever to hold the job.

"He's so comfortable with himself," Sosa says, "that he's willing to be completely open with people, and so have them look their best, to be able to give the best performance they can." Boritt, the set designer, adds: "I always say two-by-fours don't have an attitude but human beings do. For costume designers, you're dealing with that fact on a much more intimate level."

Channing confirms their statements: "There's a shorthand with William, because he understands my body. Basically, I just like being around him."

Fashions change, for sure. Designers come and go. As they say on Seventh Avenue, "One day you're in, and the next day, you're out." Long, at the ripe young age of seventy, seems eternally in. The assignments keep coming: a stage version of Agatha Christie's *Murder on the Orient Express* (2017); a musical retrospective, *Prince of Broadway* (2017), based on the career of director and producer Harold Prince; in fall 2016, a television presentation of *The Rocky Horror Picture Show* (figs. 17, 18); and also in that season, yet another Broadway musical *A Bronx Tale*.

"My story begins with the world that the director and the set designer create," Long says, "and I come in and populate it." However the story ends, William Ivey Long seems to have many chapters left in him. One can imagine more art books being turned upside down and more inspiration boards being tacked up with images that tickle and intrigue him.

If the creative world is not nearly done with him, Rudnick, his old friend, has a nice way of summing up his enduring appeal: "William," he says, "is great material."

NOTES

1. All quotations from Stockard Channing, conversation with author, January 26, 2017.
2. All quotations from Paul Rudnick, conversation with author, January 18, 2017.
3. Frank Rich, "*Nine*, a Musical Based on Fellini's *8½*," *The New York Times*, May 10, 1982, C13.
4. All quotations from William Ivey Long, conversation with author, January 5, 2017.
5. All quotations from Emilio Sosa, conversation with author, January 17, 2017.
6. Rich, "*Nine*," C13.
7. Alex Witchel, "William Ivey Long Keeps His Clothes On," *The New York Times Magazine*, January 29, 2006, http://www.nytimes.com/2006/01/29/magazine/william-ivey-long-keeps-his-clothes-on.html.
8. All quotations from Natasha Katz, conversation with author, January 22, 2017.
9. All quotations from John Schneeman, conversation with author, January 5, 2017.
10. All quotations from Beowulf Boritt, conversation with author, January 19, 2017.

THE ART AND CRAFT OF WILLIAM IVEY LONG 2007–2016

Rebecca E. Elliot

IF YOU HAVE SEEN a Broadway theatrical production either in New York or on a national tour in the last thirty-five years, you have almost certainly seen— and been dazzled by—the work of William Ivey Long. The designer continually surpasses the expectations of directors, audiences, and peers, thanks to his unparalleled knowledge of clothing construction, attention to detail, and precise visual vocabulary.[1] He won his first Tony Award for costume design in 1982 for the Broadway musical *Nine*, and since then has received five more: in 1992 for *Crazy For You*, in 2001 for *The Producers*, in 2003 for *Hairspray*, in 2007 for *Grey Gardens*, and, most recently, in 2013, for *Rodgers and Hammerstein's Cinderella*. Currently, in 2017, his costumes appear on Broadway in the new musical *A Bronx Tale*, which premiered in 2016, and in the 1996 revival of *Chicago*, the longest-running American show on Broadway, with continuous performances for over twenty-one years. Touring nationally are *Rodgers and Hammerstein's Cinderella* and *Cabaret*, featuring Long's costume designs from 1998 in the 2014 revival.[2]

The last ten years alone offer ample evidence of why Long is one of the most highly regarded costume designers of the twentieth and twenty-first centuries. Between 2007 and 2016, he designed costumes for eighteen Broadway shows, eight Off-Broadway shows, two television specials, and several concerts. From this prolific output, seven productions, reflecting a range of historical periods and dramatic approaches, have been selected for the Mint Museum's

exhibition *William Ivey Long: Costume Designs 2007–2016*. Long's theatrical creativity for the summer outdoor drama *The Lost Colony* (redesigned in 2007–8); the Broadway revivals of *The Mystery of Edwin Drood* (2012) and *On the Twentieth Century* (2015); the new Broadway musical *Rodgers and Hammerstein's Cinderella* (2013); the Kennedy Center's original production *Little Dancer* (2014); and the television specials *Grease Live!* and *The Rocky Horror Picture Show: Let's Do the Time Warp Again* (both 2016) are featured.[3] In keeping with one of the Mint Museum's focus areas—innovative contemporary craft and design—the exhibition and book explore these productions in detail to illuminate the complex process of creating theatrical costumes. Drawing mainly from Long's studio archive, the exhibition includes sketches, fitting photographs, and other preparatory materials, as well as finished costumes, in order to show the process in a step-by-step manner. In this essay, the productions are discussed in an order that reflects the degree of creative complexity involved, beginning with the relatively straightforward historicism of the long-running *The Lost Colony*, continuing with Long's ability to bring a fresh eye to the revivals included, and culminating with the new productions *Little Dancer* and *Cinderella*.

THE LOST COLONY

The Lost Colony, Paul Green's historic play dramatizing the settlement of
Roanoke Island, North Carolina, in 1587, is unique in the world of American the-
ater as a production that has run continuously for the last eighty years (fig. 19).
Long's work in 2007 on the outdoor drama—his redesign of over seven hundred
costumes used in the production, as well as the sets—came about literally by
accident, and brought him full circle to his origins as a theater professional. As
Peter Marks discusses in his essay (pp. 22–43), Long and his family have been
involved with the production since his childhood, and he has served as scenic
and costume designer from the late 1980s. Sadly, on September 11, 2007, a fire
of unknown cause destroyed the costume shop, including reference materials
and nearly the entire stock of more than fifteen hundred current and former
costumes dating back to the show's beginnings in 1937.[4] With funds raised sub-
sequently to make replacements, the company turned to Long for this task and
it became possible, for the first time in the history of the production, to design
all of the visual elements at once as a unified whole.[5]

 Long used this setback for the production as an opportunity to enrich the
show's historical accuracy. Although his own memories of the production from
the early 1950s onward were a rich resource, he did not stop there. He consulted
the names of the 115 colonists listed in the 1587 roster, as well as twentieth-
century scholarly findings linking colonists to their occupations. Whereas the
show's costumes had previously only distinguished between the upper classes
and everyone else, Long sought further differentiation that would reflect the
social classes that existed in Elizabethan England, as well as among the set-
tlement's inhabitants: besides those considered upper-class gentlemen, there
were merchants, tradespeople, farmers, and other groups.[6] Using this informa-
tion, Long and his assistants gathered numerous images from Elizabethan art,
as well as from secondary sources, to document the clothing of these different
levels of society (fig. 20). Additionally, for the Roanoke Native Americans he
consulted colonist John White's drawings of the native people based on several
expeditions to the area between 1585 and 1590 (figs. 21–23). With this historicist
approach, Long not only created a convincing and cohesive look for the show,
he also ensured that the costumes treat the actual people depicted in the drama
with respect, whether they are colonist or Native American, rich or poor.

 The second scene of act 2, known as the "Fishnet" scene, in which the
colonists work at their jobs, exemplifies how Long differentiates the male
characters through their clothing: Captain Ananias Dare, a member of the upper

class, wears an ostrich feather in his hat and a formal outfit of rich maroon color, ornamented with intricate slashing, a hallmark of Renaissance fashion that reveals additional luxurious fabrics beneath the openings (figs. 24, 25). By contrast, Anthony Cage, a skilled artisan and member of the upper-middle class, wears a simpler doublet and breeches in drab colors (fig. 26). Mark Bennett, a farmer, wears work boots and a shabbier doublet that is left unbuttoned, suggesting that he is sweaty from labor (fig. 27).

For Long, the process of re-creating Elizabethan, or indeed any, theatrical garments is as exacting as that of researching them. After the production team of *The Lost Colony* approved his designs, Long worked with some of the premier costume shops in New York on the construction of the garments. Long's meticulous photographic documentation provides a fascinating window into this step-by-step process that involves finalizing selections of fabrics and trims, making muslin patterns, designating the placements of ornamentation, and holding numerous fittings in order to achieve the final look. Bringing Long's designs to fruition in this manner requires well-honed skills and comprehensive knowledge from drapers who make the patterns, cutters who cut the fabrics into the many necessary pieces, and stitchers who sew the pattern pieces into finished costumes ready for the stage. It is a complex, tradition-rich undertaking, far removed from home sewing of theatrical costumes using store-bought patterns.[7]

Euroco Costumes, Inc. made gowns for the character of Eleanor White (future wife of Captain Ananias Dare). With his sketch in hand, Long gathered dozens of fabric swatches and discussed them with Euroco staff to determine which would work best, factoring in color, texture, and durability, especially as they relate to the needs of an outdoor drama such as *The Lost Colony* (figs. 28, 29). At Jennifer Love, Inc., another New York costume shop, groups of selected fabrics for particular costumes, in this case doublets for the character of Arthur Barlowe, were reviewed (fig. 30). Long's studio provided yardage of the chosen fabrics to the shop, where it was sorted by sketch. For the next stage in the process, the staff at Jennifer Love Costumes, Inc. padded dress forms according to the body measurements of either the actor or a fit model. Muslin mock-ups of the designs were presented on the forms so that details of pattern cuts could be worked out before cutting the expensive fabrics.

Fittings at Tricorne, LLC for Sir Walter Raleigh's costume for the "Queen's Garden" scene show additional steps of building costumes. On a fit model wearing a muslin mock-up of a slashed doublet front, as well as a ruff, breeches, and

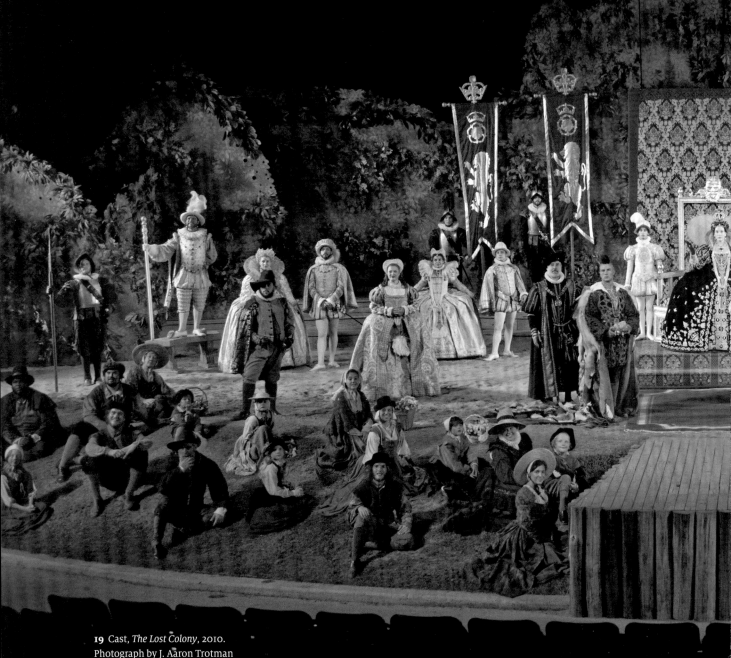

19 Cast, *The Lost Colony*, 2010.
Photograph by J. Aaron Trotman

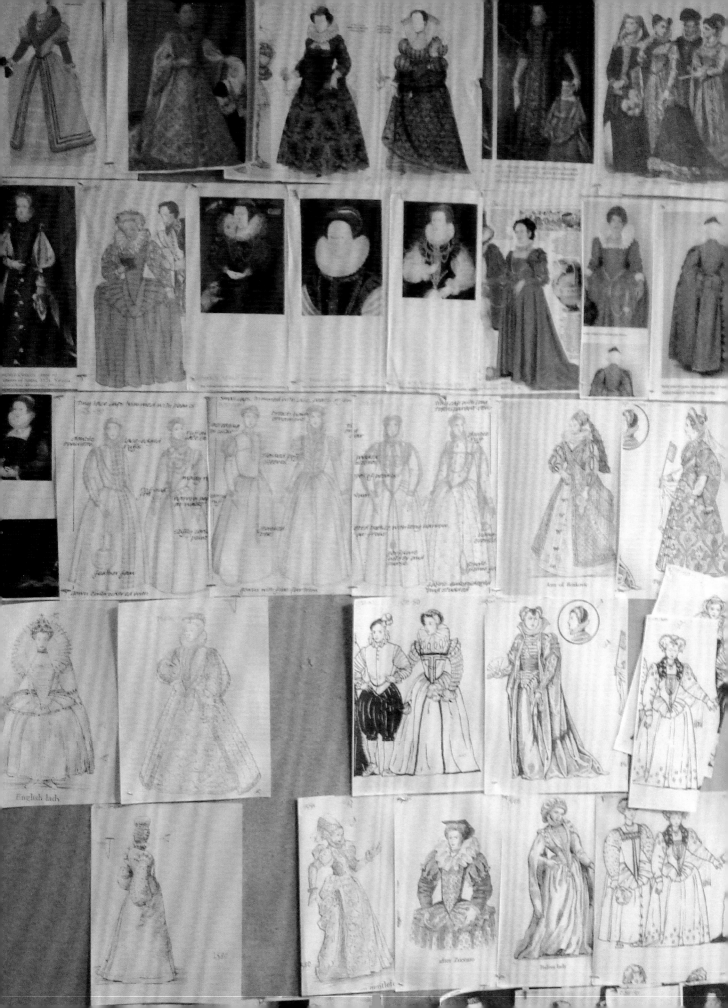

decorative trims, Long drew the intended location of the slashes on the muslin (figs. 31–33). This process typically requires at least three fittings: one with the muslin mock-up, the second with the actual costume in progress, and the final with the finished costume. On-site in North Carolina, the actor playing the role tried on his costume, while Long compared it with the 1588 portrait of Raleigh, housed in the National Portrait Gallery, London, that it imitates (fig. 34). As in the painting, Raleigh's costume is dripping with pearls (though faux substitute for real), befitting his status as a gentleman favored by the powerful Queen Elizabeth I (fig. 35).

Costumes for the play's other main characters, in particular Queen Elizabeth's two sumptuous gowns, received the same level of attention to detail as did Raleigh's (figs. 36–41). Long and his team reviewed many portraits of the queen; ultimately the most influential were the Hardwick Portrait (1592–99), in Hardwick Hall, Derbyshire, England; and the Armada Portrait (ca. 1588), attributed to George Gower, at Woburn Abbey, Bedfordshire, England. The costume for the "Queen's Garden" scene closely follows the Hardwick Portrait, except that instead of a beige underskirt depicting flora and fauna, the costume substitutes a dark underskirt with gold trim in order to make it more visible at a distance. As with those for Raleigh, the costumes and jewelry include numerous faux pearls and gems. Beneath each of the queen's gowns is a large farthingale, the specially shaped underskirt that gives dresses of that time their voluminous dimensions.

OPPOSITE
20 Inspiration board, *The Lost Colony*, 2008

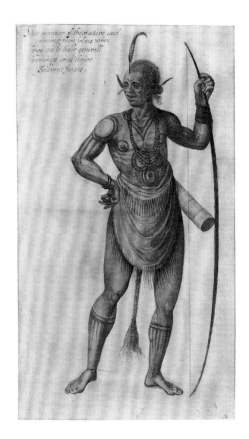

21 John White, illustration of Roanoke Native American, 1585–93. Watercolor, graphite, and gold on paper. © Trustees of the British Museum

22 Sketch for Chief Manteo, "Indian Corn Dance" scene, *The Lost Colony*, 2008. Graphite, gouache, and watercolor on Bristol board

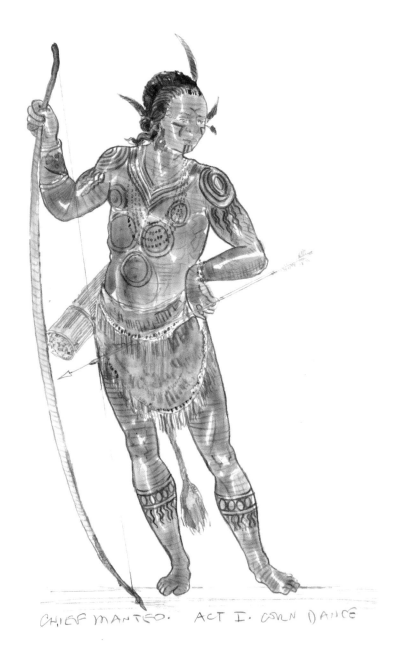

CHIEF MANTEO. ACT I. CORN DANCE

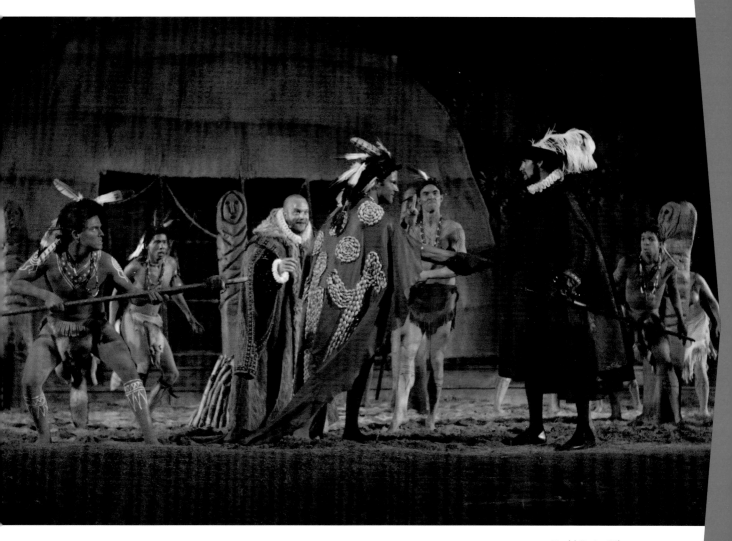

23 David Carter (King
Wingina, center), Ian
Potter (Philip Amadas,
right), Nathan Bennett
(historian, center),
Michael Campion
(Chief Wanchese, far
left), and Clay White
(Chief Manteo, center
back), "Indian Corn
Dance" scene, *The
Lost Colony*, 2008.
Photograph by J. Aaron
Trotman

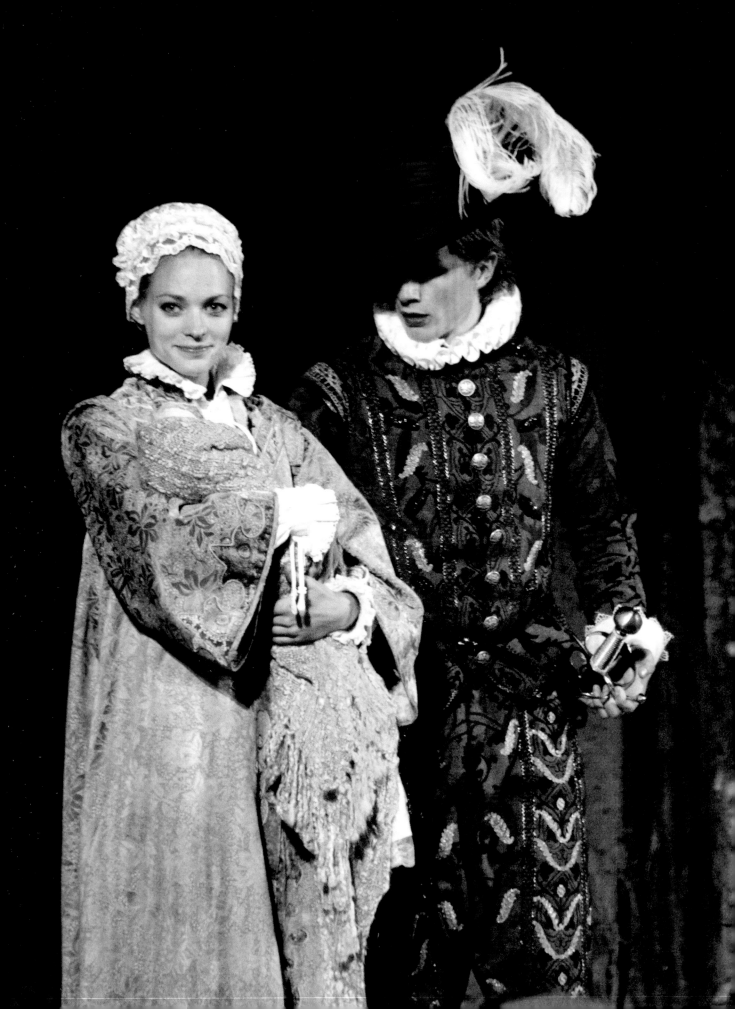

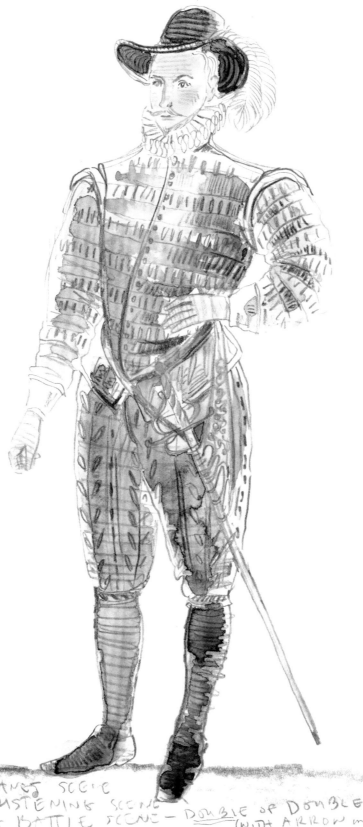

24 Madeline Hamer
(Eleanor White Dare)
and Pressly Coker
(Captain Ananias Dare),
"Christening" scene,
The Lost Colony, 2008.
Photograph by Duane
Cochran

25 Sketch for
Captain Ananias
Dare, "Fishnet,"
"Christening," and
"Big Battle" scenes,
The Lost Colony, 2008.
Graphite, gouache,
and watercolor on
Bristol board

FISHNET SCENE
CHRISTENING SCENE
BIG BATTLE SCENE — DOUBLE OF DOUBLET
(WITH ARROW IN BACK)
ANANIAS DARE

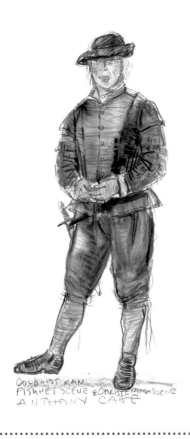

COLONIST MAN
FISHNET SCENE & CHRISTENING SCENE
ANTHONY CAGE

COLONIST MAN
FISHNET SCENE
CHRISTENING SCENE
MARKE BENNET

CLOCKWISE FROM
UPPER RIGHT
26 Sketch for Anthony
Cage, "Fishnet" scene,
The Lost Colony, 2008.
Graphite, gouache, and
watercolor on Bristol
board

27 Sketch for Mark
Bennett, "Fishnet" and
"Christening" scenes,
The Lost Colony, 2008.
Graphite, gouache,
and watercolor on
Bristol board

28 Sketch for Eleanor
White, "Queen's
Garden" scene, *The
Lost Colony*, 2008.
Graphite, gouache, and
watercolor on Bristol
board

OPPOSITE, TOP AND
BOTTOM
29 William Ivey
Long and Stephanie
Pezolano (Euroco
Costumes, Inc.)
discussing swatches
for Eleanor White
costumes, *The Lost
Colony*, Euroco
Costumes, Inc., New
York, 2008. Photograph
by Donald Sanders

30 Mariah Hale
(associate costume
designer), Jennifer
Love, and William
Ivey Long discussing
swatches for Arthur
Barlowe costume, *The
Lost Colony*, Jennifer
Love Costumes, Inc.,
New York, 2008.
Photograph by Donald
Sanders

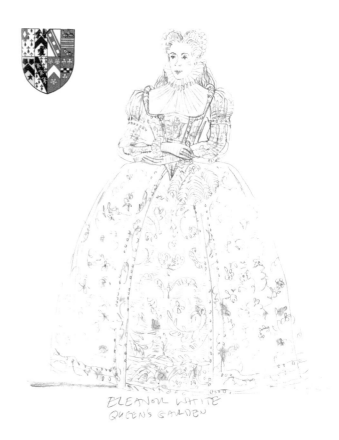

ELEANOR WHITE
QUEEN'S GARDEN

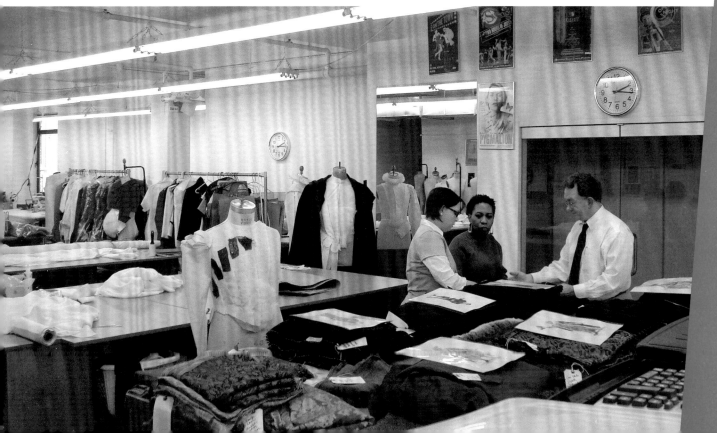

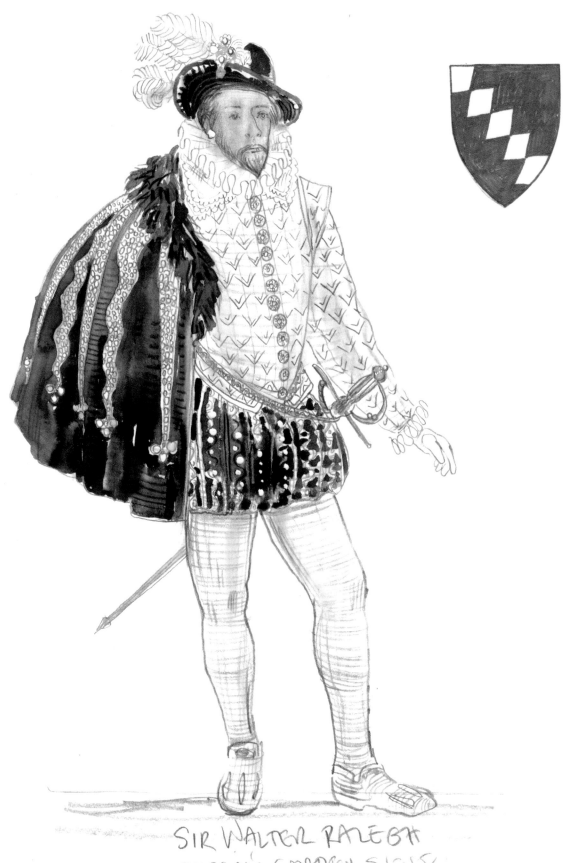

SIR WALTER RALEGH
QUEEN'S GARDEN SIEGE

31 Sketch for Sir Walter
Raleigh, "Queen's
Garden" scene, *The Lost
Colony*, 2008. Graphite,
gouache, and watercolor
on Bristol board

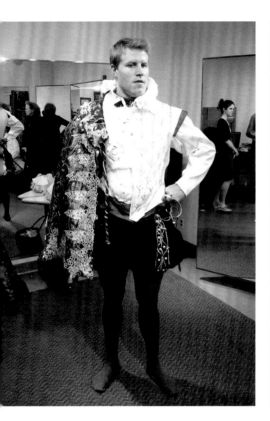

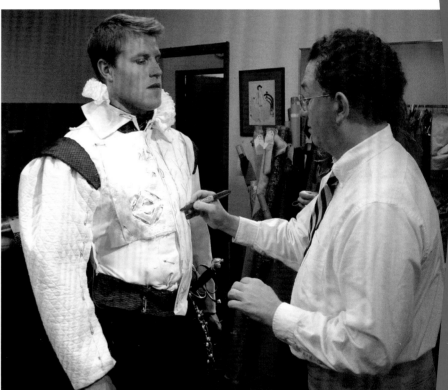

32 Fit model Chad
Carpenter, muslin
fitting for Sir Walter
Raleigh, "Queen's
Garden" scene, *The
Lost Colony*, Tricorne,
LLC, 2008. Photograph
by Will Lowry

33 William Ivey Long
and fit model Chad
Carpenter, muslin
fitting for Sir Walter
Raleigh, "Queen's
Garden" scene, *The
Lost Colony*, Tricorne,
LLC, 2008. Photograph
by Will Lowry

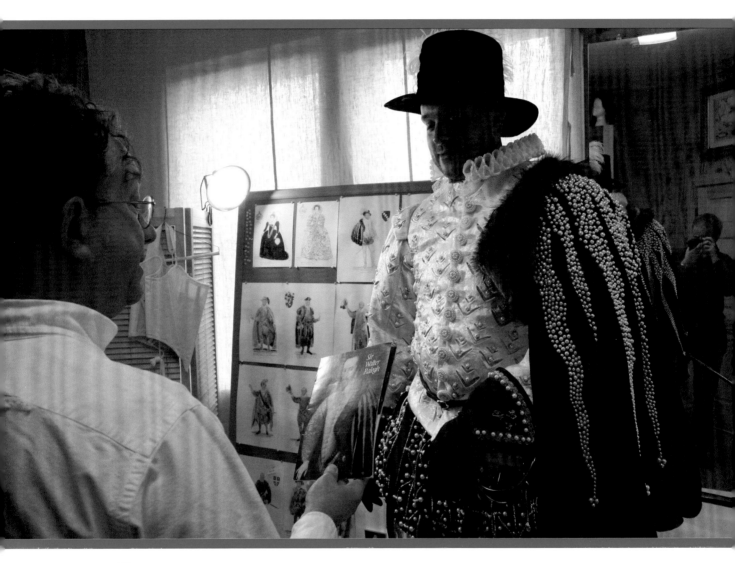

34 William Ivey
Long and Nathan
Bennett (Sir Walter
Raleigh), *The Lost
Colony*, Manteo,
North Carolina, 2008.
Photograph by Will
Lowry

OPPOSITE
35 Nathan Bennett
(Sir Walter Raleigh),
The Lost Colony, 2008.
Photograph by William
Ivey Long

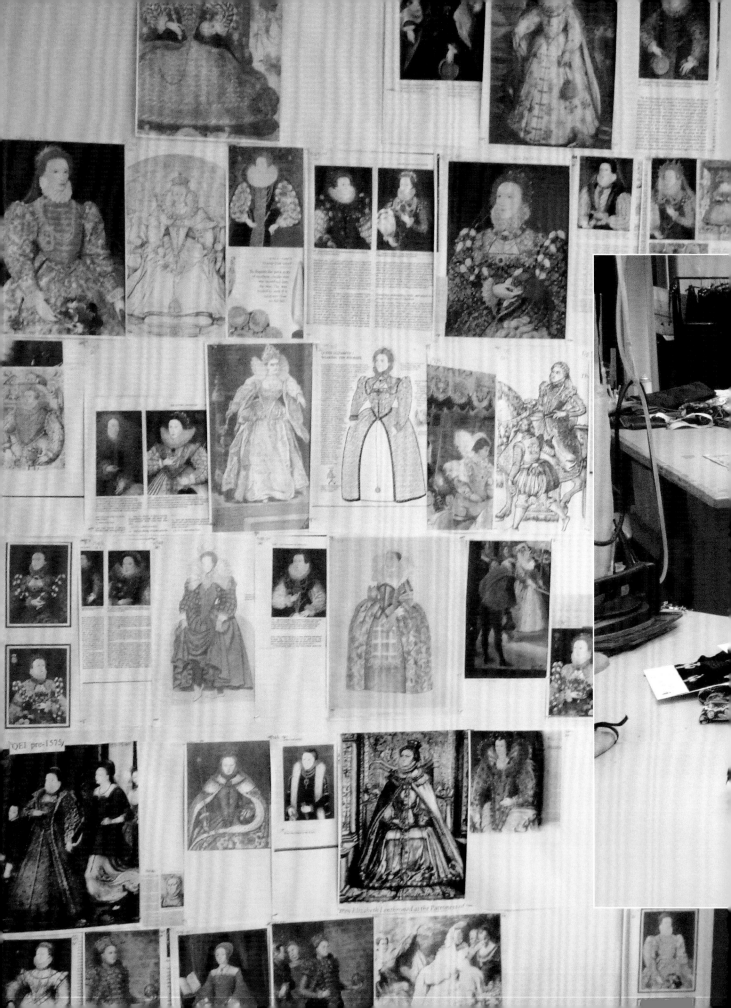

OPPOSITE
36 Inspiration board
for Queen Elizabeth I,
The Lost Colony, 2008

37 William Ivey
Long and Carolyn
Kostopoulos (Carelli
Costumes, Inc.),
discussing Queen
Elizabeth's costumes,
The Lost Colony, Carelli
Costumes, Inc., New
York, 2008. Photograph
by Will Lowry

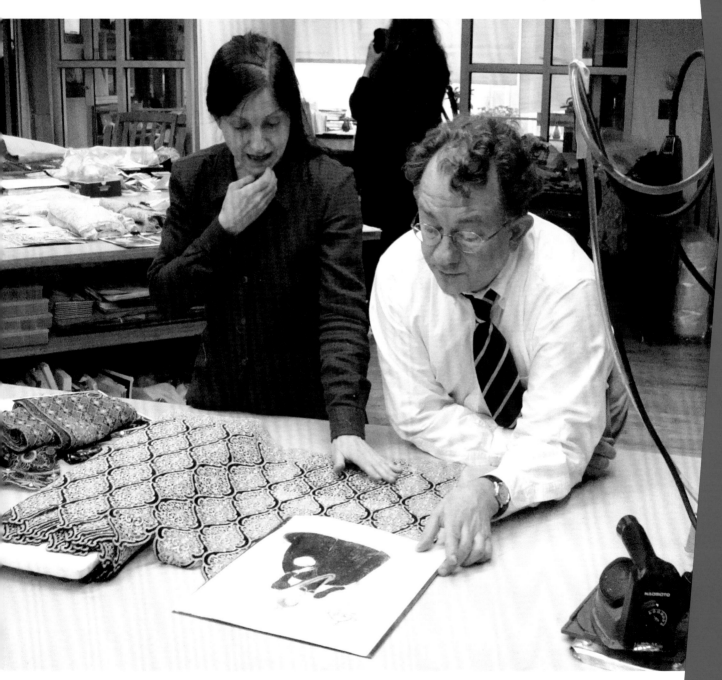

38 Hugh Hanson (Carelli Costumes, Inc.), Nikki Ferry (Queen Elizabeth I), and a costume technician (Carelli Costumes, Inc.), muslin fitting, "Queen's Garden" scene, *The Lost Colony*, Carelli Costumes, Inc., New York, 2008. Photograph by Will Lowry

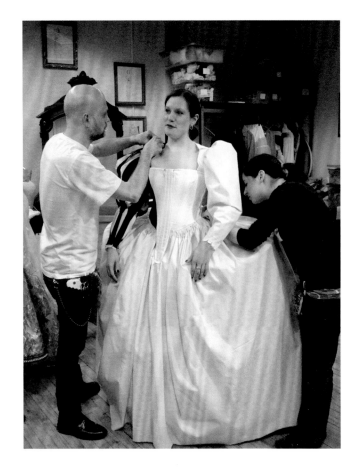

39 Donald Sanders (William Ivey Long Studios), Nikki Ferry (Queen Elizabeth I), and Hugh Hanson (Carelli Costumes, Inc.), fitting, "Queen's Chamber" scene, *The Lost Colony*, Carelli Costumes, Inc., New York, 2008. Photograph by Donald Sanders

OPPOSITE
40 Nikki Ferry (Queen Elizabeth I) and Terry Snead (Governor White), "Queen's Chamber" scene, *The Lost Colony*, 2008. Photograph by J. Aaron Trotman

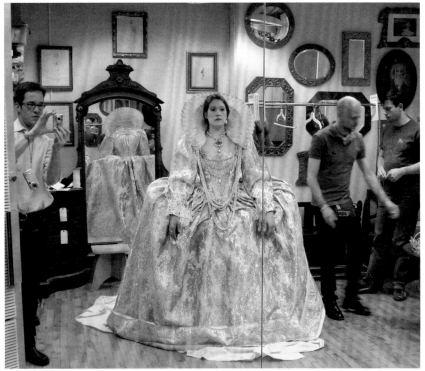

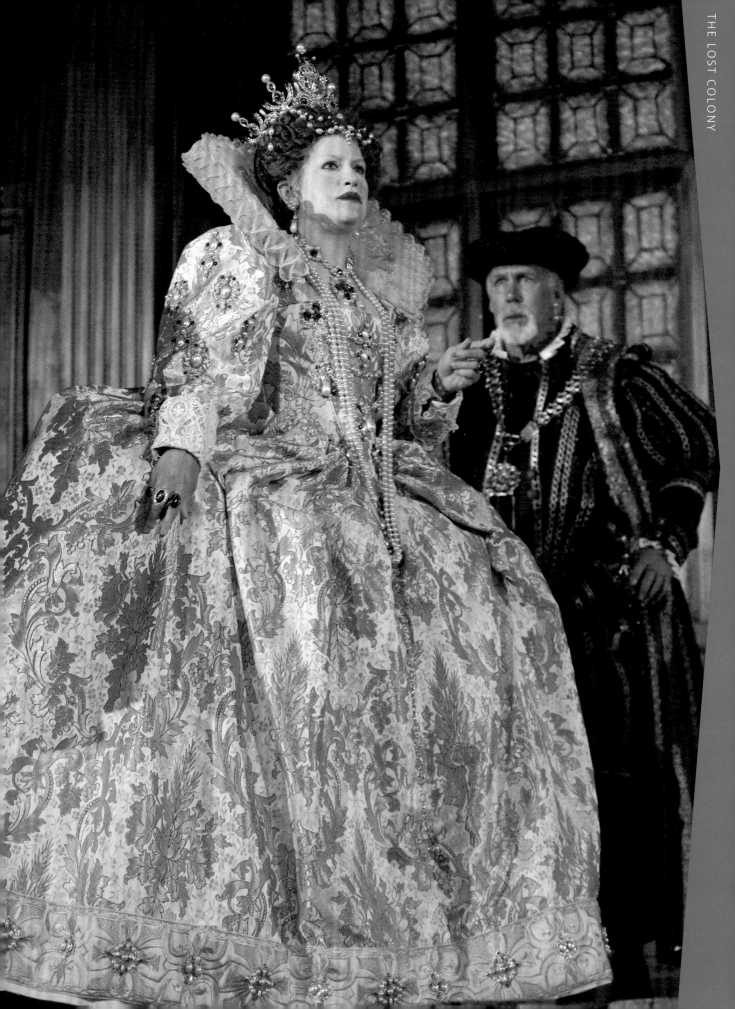

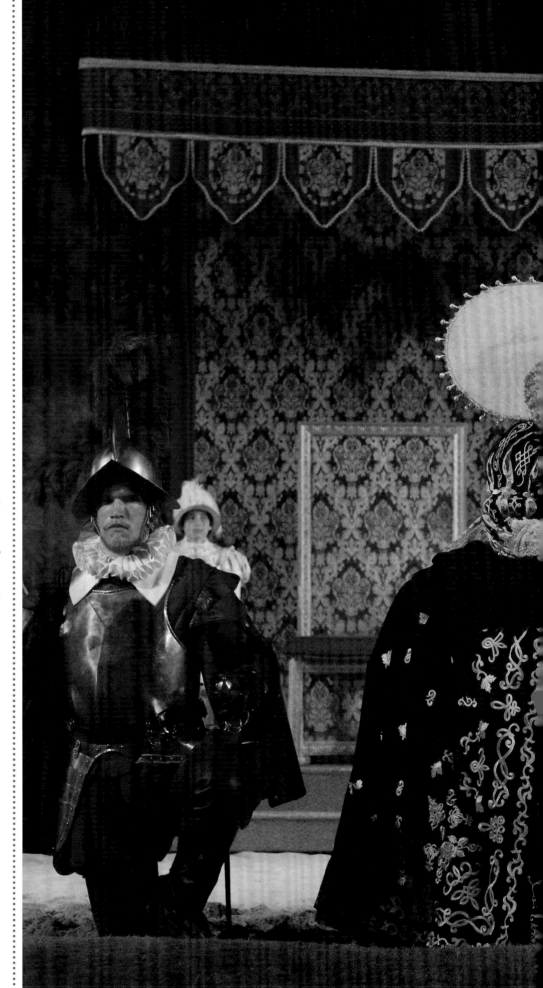

41 Nikki Ferry (Queen
Elizabeth I), P. J. Miller
(left, first soldier),
Matthew Patrick
(right, second soldier),
courtiers, and pages,
"Queen's Garden"
scene, *The Lost Colony*,
2008. Photograph by
J. Aaron Trotman

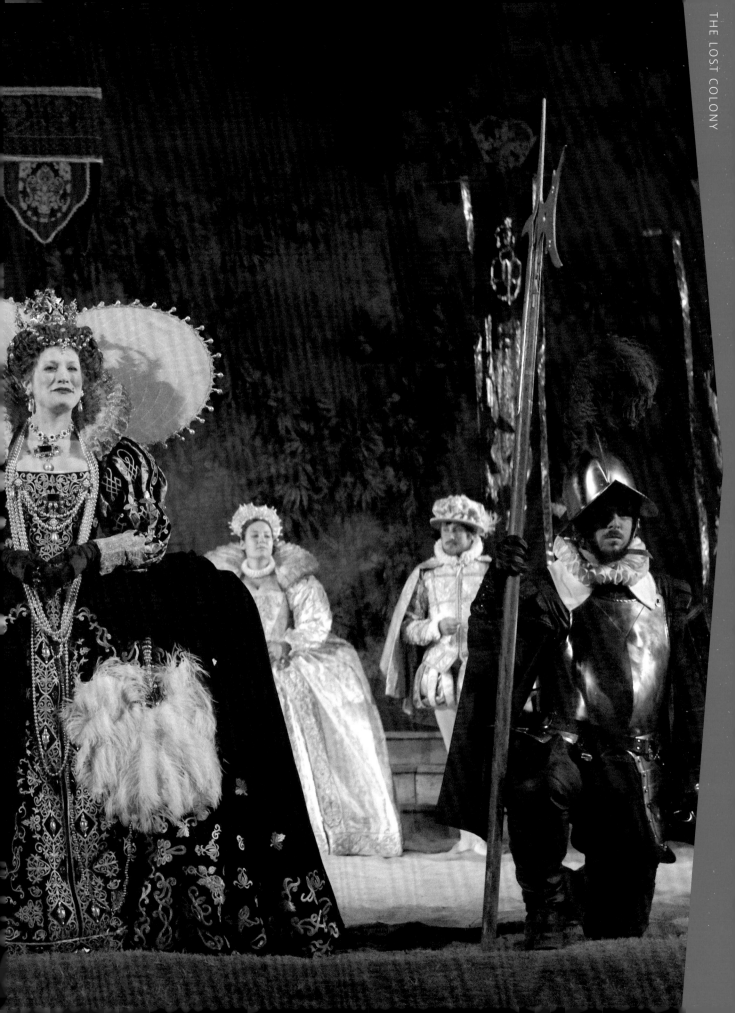

THE MYSTERY OF EDWIN DROOD

The Mystery of Edwin Drood, written in the early 1980s by Rupert Holmes, is a
Victorian-style melodrama and play-within-a-play (figs. 42, 43). In 1895 London,
a troupe of music hall actors presents their new play based on the murder
mystery that was left unfinished, and unsolved, by Charles Dickens when he
died in 1870. After the title character mysteriously disappears and all of his
acquaintances have emerged as suspects, the Victorian troupe halts the play and
asks the audience to vote on which character is the murderer, which character
is disguised as the investigator, and which two are secretly lovers (fig. 44). Each
night a different ending is performed based on the audience's vote, allowing for
dozens of permutations. The characters include John Jasper, a choirmaster and
secret opium addict who is in love with his young student, Rosa Bud; Edwin
Drood, Jasper's nephew and Rosa's betrothed; Princess Puffer, who runs an opi-
um den; and Neville and Helena Landless, brother and sister from an unnamed
South Asian country (Ceylon in Dickens's original). No matter what the ending,
the mood of the show, and the portrayal of the characters, is sly, tongue-in-
cheek, and slightly camp.

Long's research for *The Mystery of Edwin Drood* reflects a new approach
he began using in 2009 after relocating his studio to Manhattan's Tribeca
neighborhood. This large workspace allows the designer to compile his research
in a more immersive way than was previously possible. Using 8-by-4-foot foam
insulation boards and kraft paper, Long and his assistants create collages of
images with which he surrounds himself, ultimately absorbing their impact
through a combination of close study and osmosis (fig. 45). For *The Mystery of
Edwin Drood*, inspiration included Victorian music halls, men's and women's
fashions, past theatrical adaptations of Dickens's story, and especially, book
illustrations. Long gathered as many illustrations from different editions
of Dickens's writings as he could find, the better to channel a Dickensian
sensibility in representing the characters visually.

The resulting costumes vividly convey the play's nineteenth-century
personages. Playwright Rupert Holmes describes John Jasper as a precursor
to Robert Louis Stevenson's character Dr. Jekyll/Mr. Hyde, who was created by
Stevenson the decade following Dickens's death.[8] Outfitted somberly, in a black
frock coat, waistcoat, and tie, Jasper is the picture of Victorian propriety (figs.
44, 46); in the opium den, however, he is disheveled and drug addled in a dingy
undershirt, suspenders, and trousers (fig. 47). Rosa Bud, meanwhile, has the
aura of an ingénue, in a ruffled dress of light blue that not only complements

her blonde hair, but is also a color that has been used to signify purity throughout the history of art, notably in depictions of the Virgin Mary (figs. 48, 49). Long, in his twist on the iconography, calls this color "victim blue"; here it accords with Rosa's status as Jasper's prey, the subject of his unseemly attentions.[9] Yet, as the plot thickens, Rosa begins to seem less innocent, and her blue dress becomes a red herring: an unreliable clue to character. Contrasting with them both is Edwin Drood, whose costume presents a peculiar problem. The casting follows the Victorian tradition of a breeches role in which women portrayed men, dressing in men's clothes, yet without actually disguising their gender. Long marks Drood as a central character with a striking, blue frock coat, brocaded and embroidered red vest, and blue pin-striped trousers, all expertly tailored in the manner of late Victorian menswear (figs. 50, 51).

42 Costume for Shannon Lewis as Miss Florence Gill (detail), "There You Are," *The Mystery of Edwin Drood*, 2012. Photograph by Irving Solero

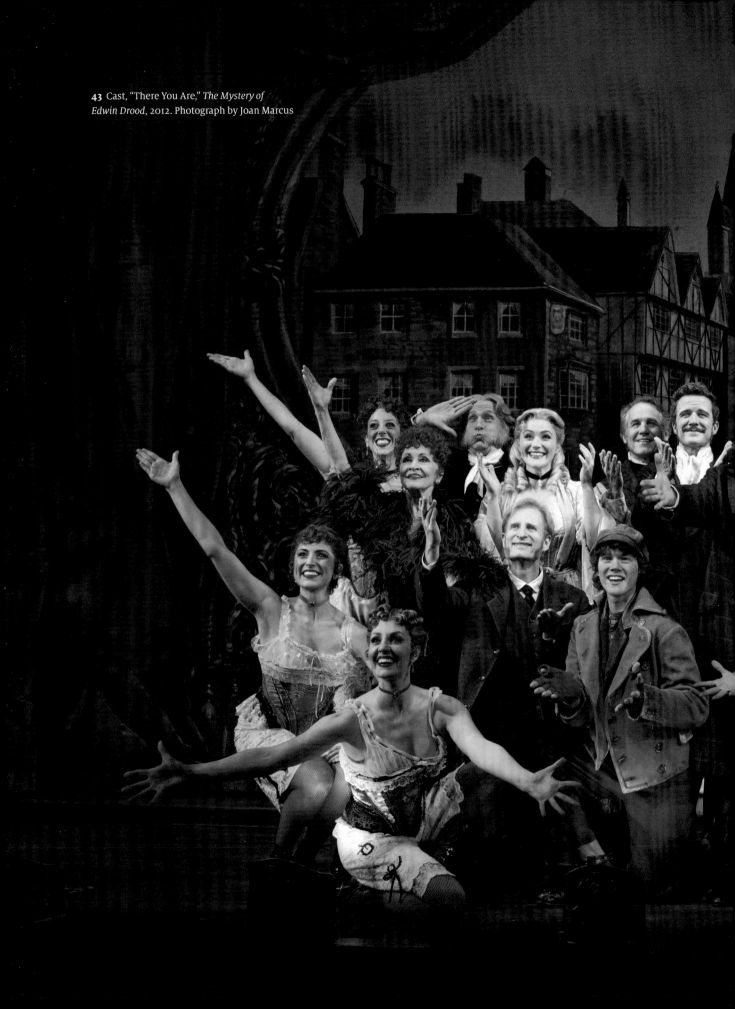

43 Cast, "There You Are," *The Mystery of Edwin Drood*, 2012. Photograph by Joan Marcus

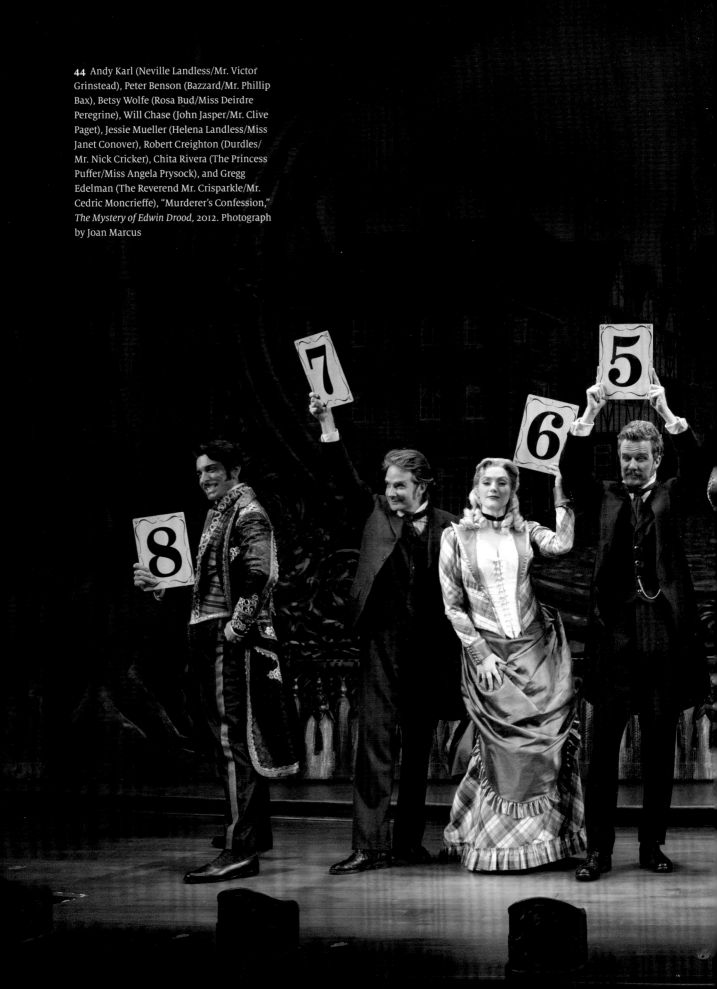

44 Andy Karl (Neville Landless/Mr. Victor Grinstead), Peter Benson (Bazzard/Mr. Phillip Bax), Betsy Wolfe (Rosa Bud/Miss Deirdre Peregrine), Will Chase (John Jasper/Mr. Clive Paget), Jessie Mueller (Helena Landless/Miss Janet Conover), Robert Creighton (Durdles/Mr. Nick Cricker), Chita Rivera (The Princess Puffer/Miss Angela Prysock), and Gregg Edelman (The Reverend Mr. Crisparkle/Mr. Cedric Moncrieffe), "Murderer's Confession," *The Mystery of Edwin Drood*, 2012. Photograph by Joan Marcus

45 William Ivey Long's
studio, New York, 2017.
Photograph by Irving
Solero.

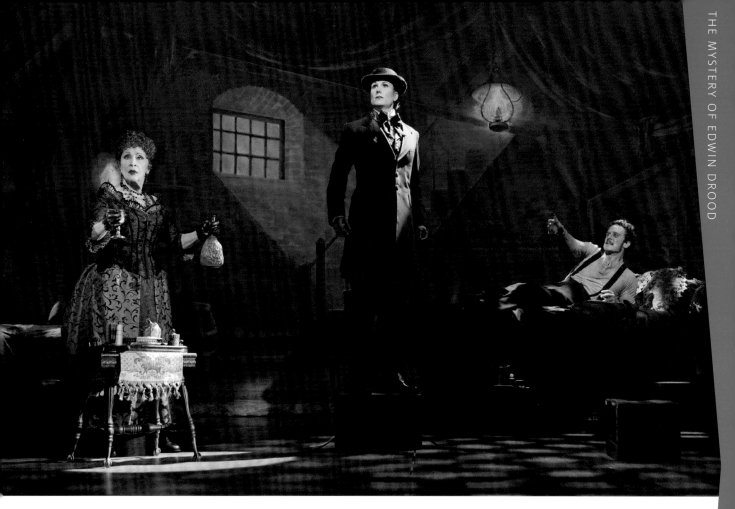

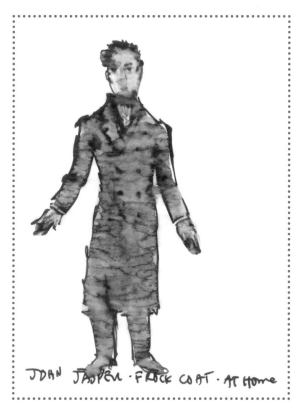

47 Chita Rivera (The Princess Puffer/Miss Angela Prysock), Stephanie J. Block (Edwin Drood/Miss Alice Nutting), and Will Chase (John Jasper/ Mr. Clive Paget), *The Mystery of Edwin Drood*, 2012. Photograph by Joan Marcus

46 Sketch for John Jasper, "A Man Could Go Quite Mad," *The Mystery of Edwin Drood*, 2012. Ink, gouache, watercolor, and colored pencil on tracing paper

48 Andy Karl (Neville Landless/ Mr. Victor Grinstead), Gregg Edelman (The Reverend Mr. Crisparkle/Mr. Cedric Moncrieffe), Jessie Mueller (Helena Landless/Miss Janet Conover), and Betsy Wolfe (Rosa Bud/Miss Deirdre Peregrine), "Moonfall Quartet," *The Mystery of Edwin Drood*, 2012. Photograph by Joan Marcus

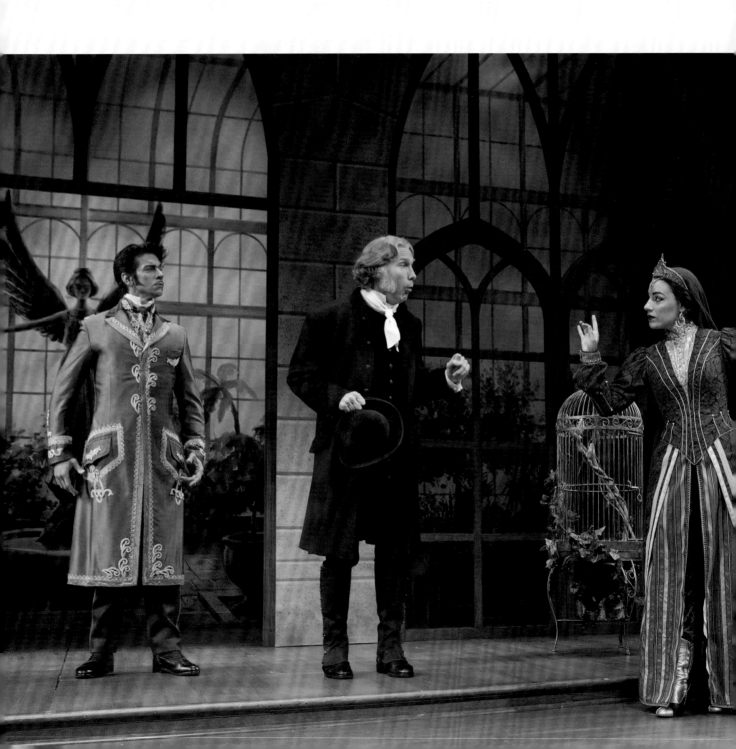

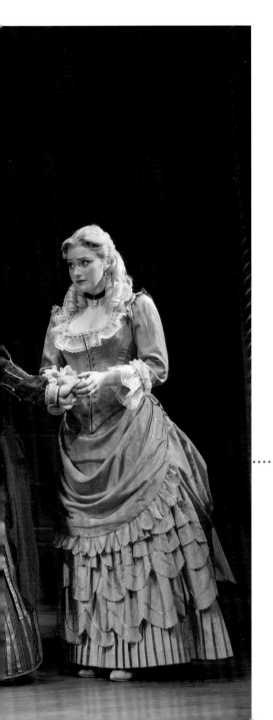

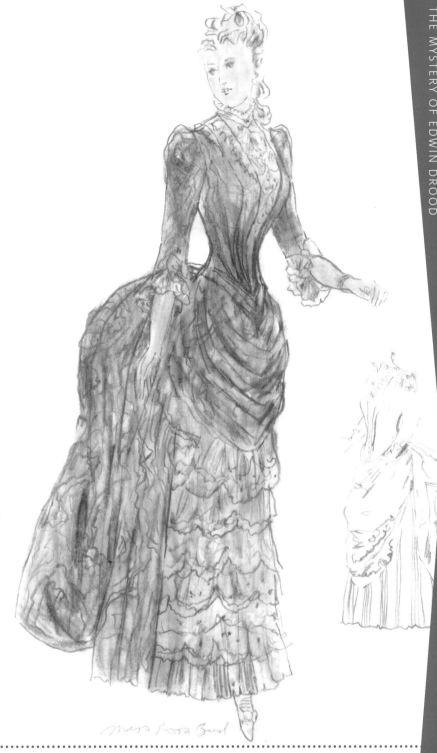

49 Sketch for Rosa
Bud, act 1, *The Mystery
of Edwin Drood,* 2012.
Graphite, gouache,
watercolor, and ink on
Bristol board

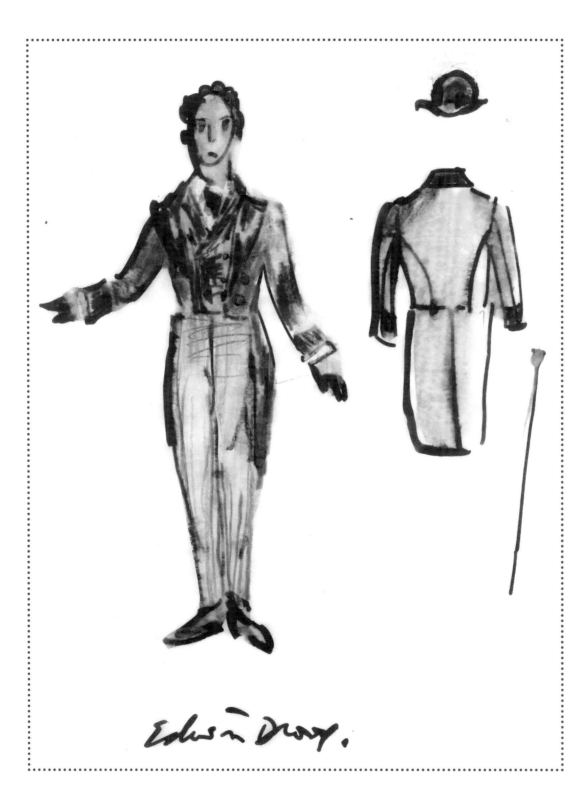

Edwin Drood.

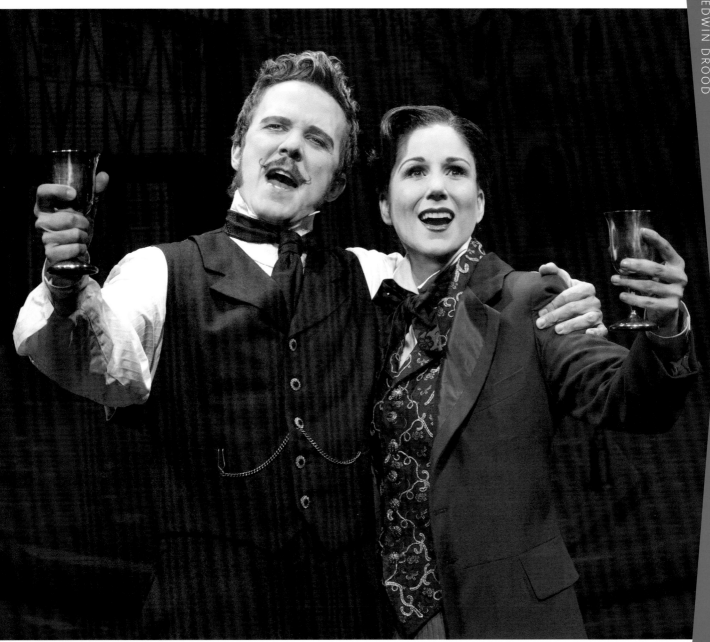

OPPOSITE
50 Sketch for Edwin Drood, act 1, *The Mystery of Edwin Drood*, 2012. Ink, gouache, watercolor, and colored pencil on tracing paper

51 Will Chase (John Jasper/Mr. Clive Paget) and Stephanie J. Block (Edwin Drood/ Alice Nutting), "Two Kinsmen," *The Mystery of Edwin Drood*, 2012. Photograph by Joan Marcus

ON THE TWENTIETH CENTURY

For the 2015 revival of *On the Twentieth Century*, Long's designs capture the energy and glamour of American art deco fashions of the late 1930s, his "absolute favorite" period to design (figs. 52, 53).[10] Written by Betty Comden and Adolph Green, and originally staged in 1978, the show is based on several previous plays and a 1934 movie titled *Twentieth Century*. On board the luxurious Twentieth Century Limited high-speed train, traveling from Chicago to New York in sixteen hours, financially strapped theatrical producer Oscar Jaffee must not only write a new play, but also convince famous Hollywood actress, former protégée, and old flame Lily Garland to star in it before they arrive (figs. 54, 55). Unsurprisingly, they fall in love again, but along the way, the audience is witness to outsize egos and incredible star power as the two characters butt heads.

For this project, Long's research was wide ranging, encompassing period examples of diverse garments for both men and women that appear throughout the play, from semiformal gowns, to sleepwear, to porter uniforms. Publicity photographs and film stills of 1930s Hollywood actors provided visuals for the slinky glamour Long hoped to achieve. Lily is introduced through a flashback that ends with her performing a show-stopping musical number as Veronique, the heroine of the Franco-Prussian War, so Long also looked at clothing for nineteenth-century French revolutionaries, stereotypical French citizens, and Prussian military officers. He then synthesized all of his research into costumes that are extravaganzas of color and movement, yet perceptively distinguish Lily and Oscar from the supporting cast. Lily, for example, often wears ivory silk charmeuse—a color and fabric indelibly associated with 1930s starlets such as Jean Harlow—to convey her status, as well as to set her apart from the bright palette and geometric patterns worn by the train's other female passengers. The one major exception is the song "Veronique," in which Lily, naturally, wears the colors of the French flag (fig. 56).

52 Board with scene renderings and sketches for ensemble, "On the Twentieth Century," *On the Twentieth Century*, 2014. Graphite, colored pencil, ink, gouache, watercolor, and collage on Bristol board

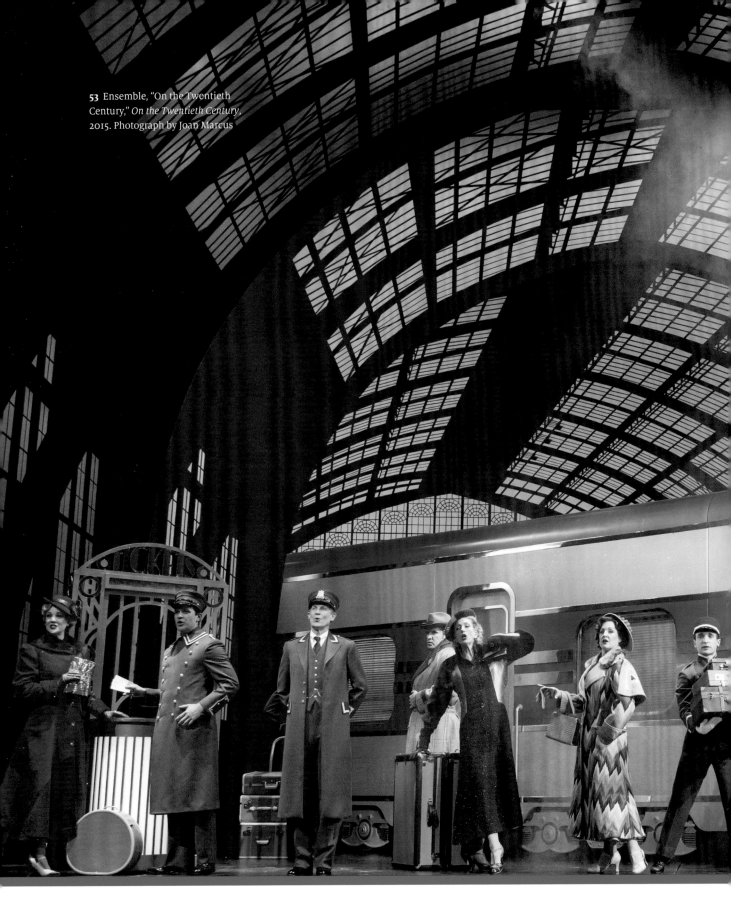

53 Ensemble, "On the Twentieth Century," *On the Twentieth Century*, 2015. Photograph by Joan Marcus

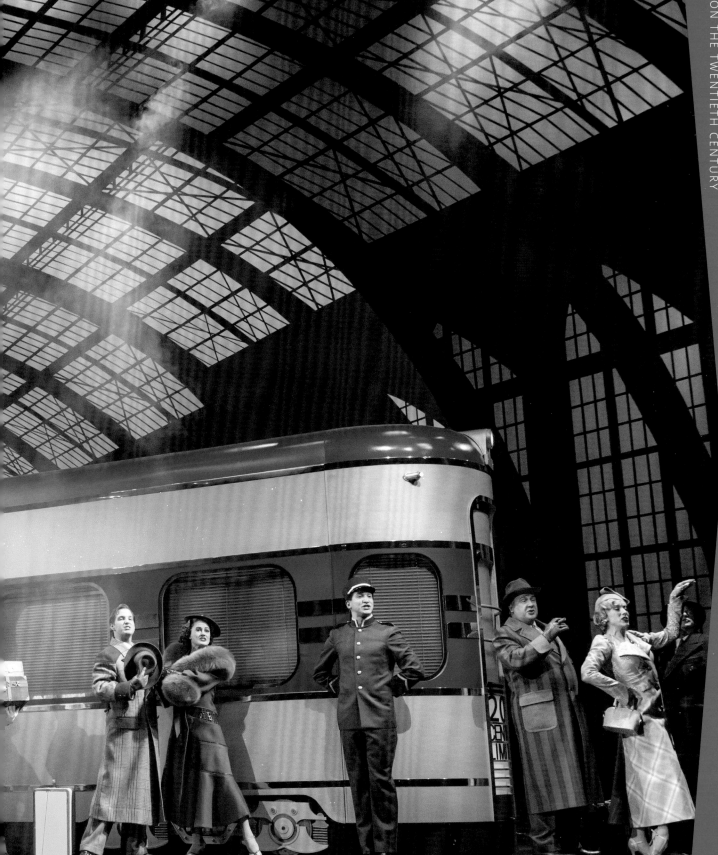

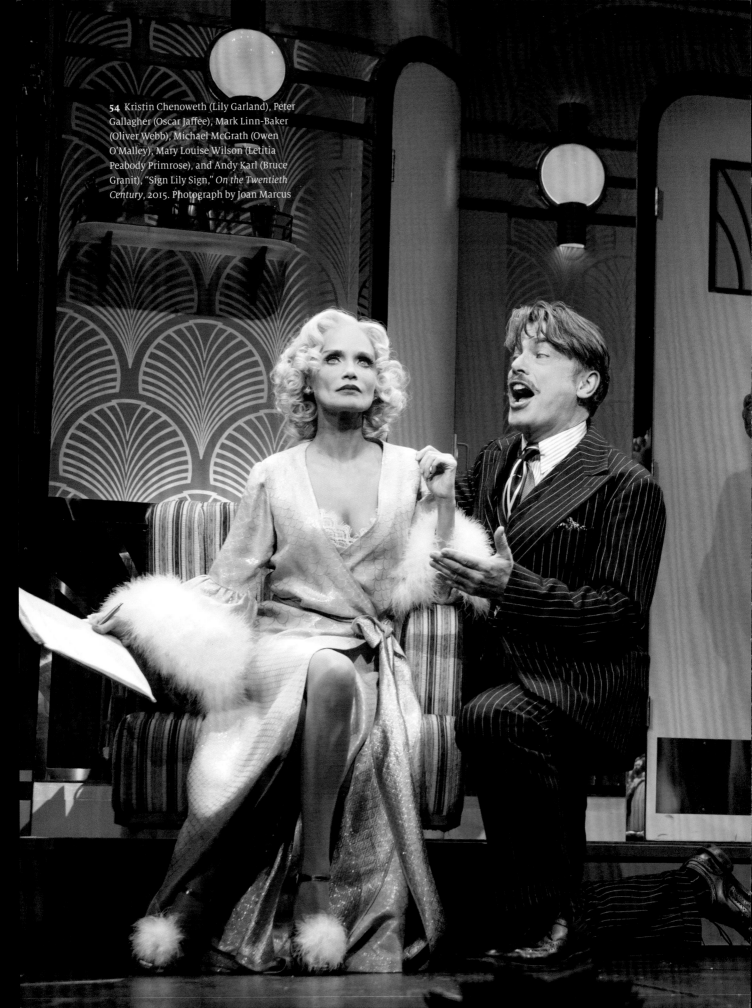

54 Kristin Chenoweth (Lily Garland), Peter Gallagher (Oscar Jaffee), Mark Linn-Baker (Oliver Webb), Michael McGrath (Owen O'Malley), Mary Louise Wilson (Letitia Peabody Primrose), and Andy Karl (Bruce Granit), "Sign Lily Sign," *On the Twentieth Century*, 2015. Photograph by Joan Marcus

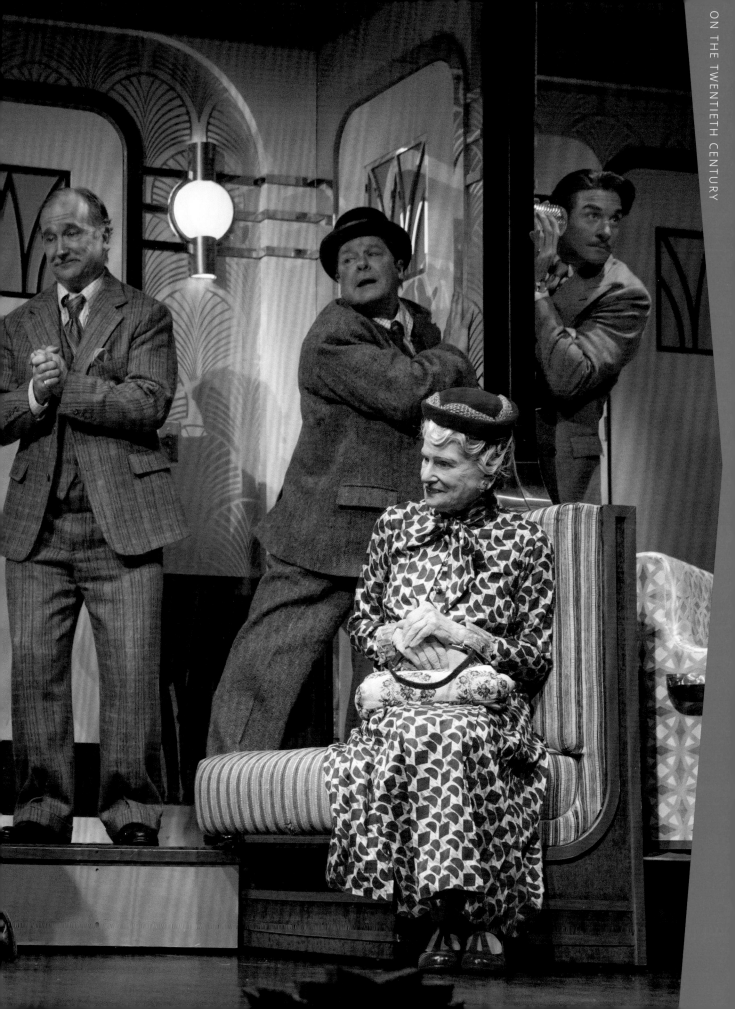

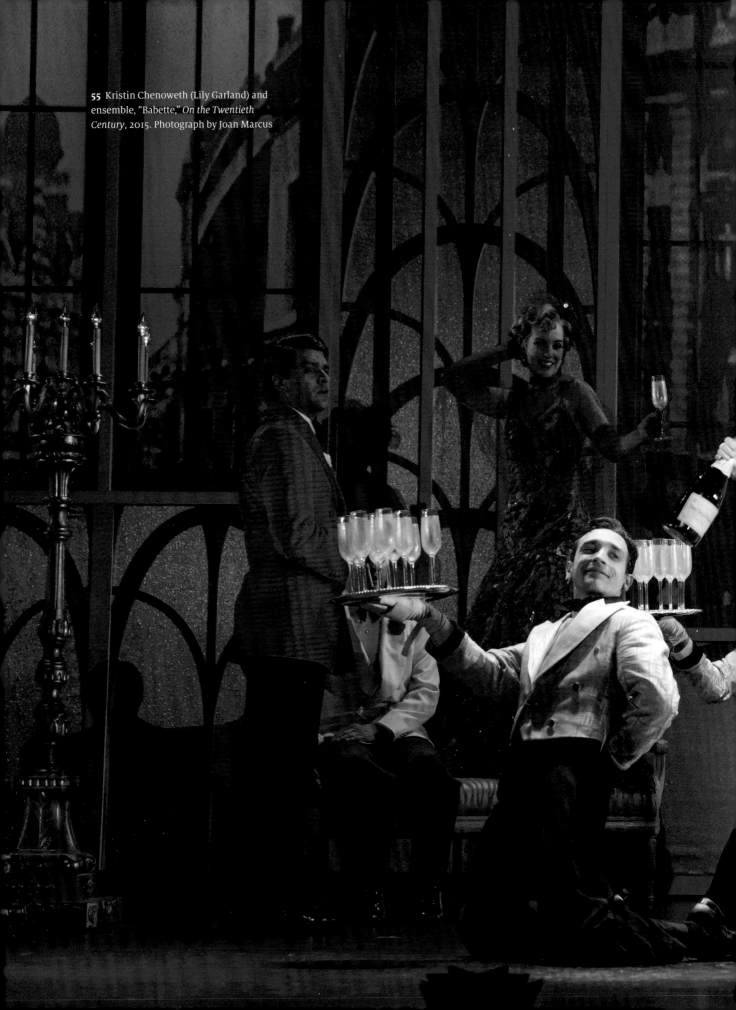

55 Kristin Chenoweth (Lily Garland) and ensemble, "Babette," *On the Twentieth Century*, 2015. Photograph by Joan Marcus

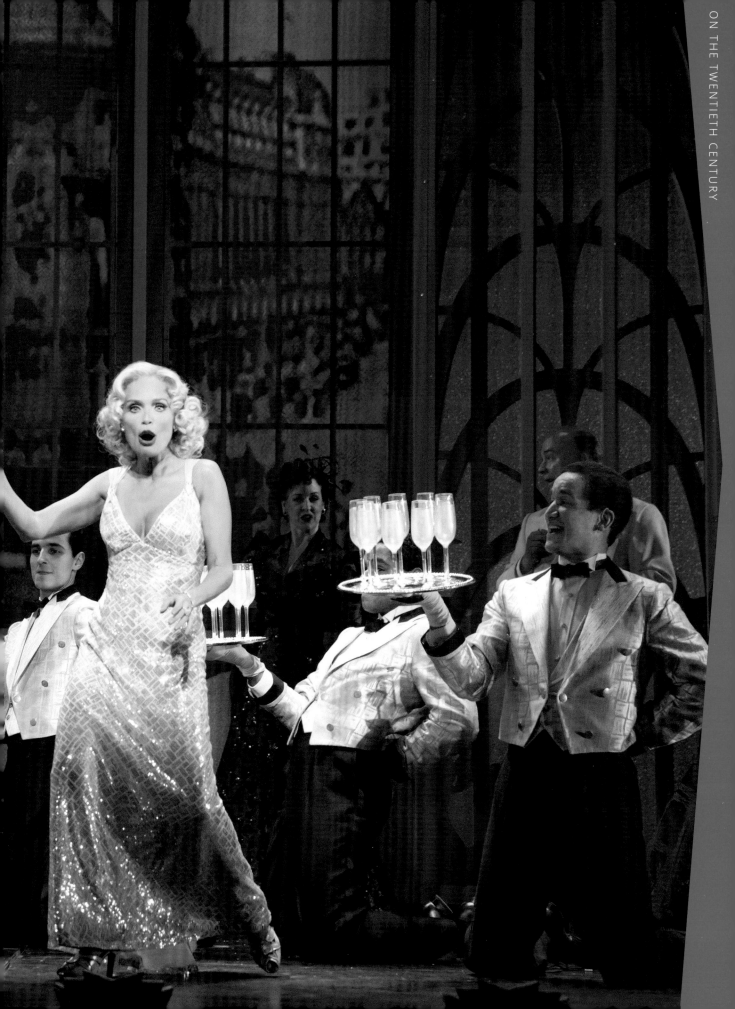

56 Kristin Chenoweth
(Lily Garland) and
ensemble, "Veronique,"
*On the Twentieth
Century*, 2015.
Photograph by Joan
Marcus

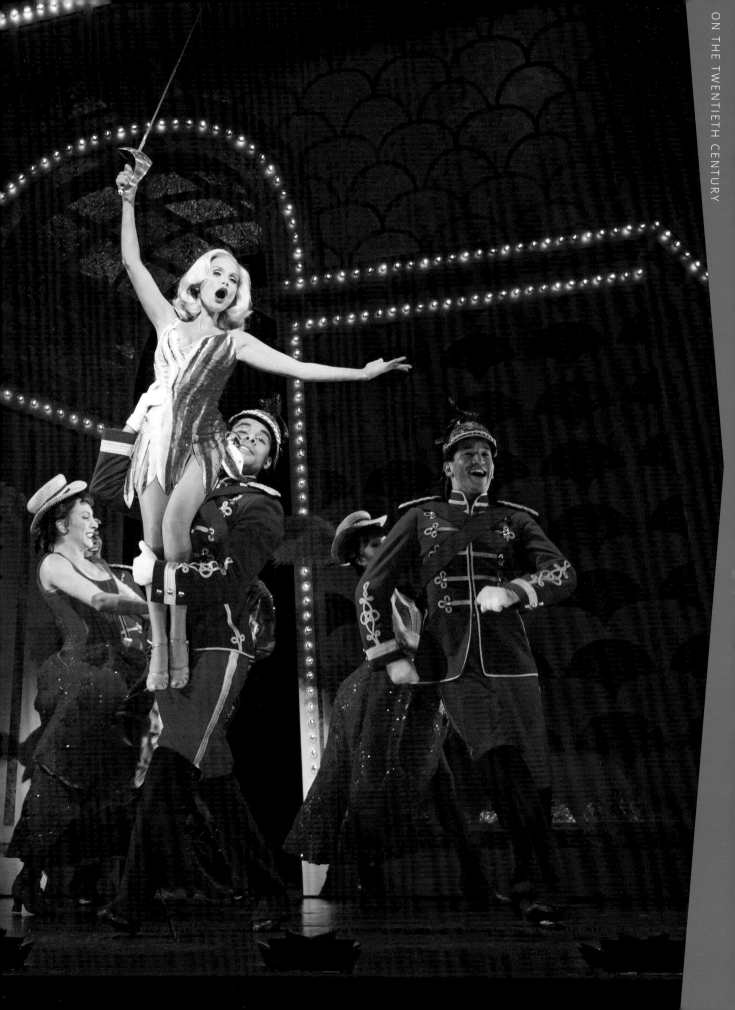

GREASE LIVE!

The televised special *Grease Live!* that aired on January 31, 2016, is a revival of the 1978 film *Grease*, which was, in turn, based on the 1971 Broadway musical. For the special, the producers chose to pay homage to several of the iconic costumes of the original film. While this situation might appear to make for a straightforward design process for Long, the project presented new challenges because of its innovative, hybrid format, somewhere between a stage musical, a film, and a live reality television show. Not only was it broadcast live, it also entailed close-ups, multiple camera angles, outfits for a large cast of extras, and quick, on-camera costume changes.

To coordinate all of this clothing—the equivalent of an entire high school in 1959—Long's research included the 1978 film, 1950s high school yearbooks, Sears and Roebuck catalogs, and various sources of 1950s teenage fashions. Pictures of James Dean, Marlon Brando, and other "bad boys" helped ground the depictions of the main character Danny Zuko (fig. 59), his friends in the T-Birds gang, and their rivals the Scorpions. Inspiration also came from an unexpected, noncontemporary source: the 1980s paintings of Jean-Michel Basquiat, which provided color schemes, as well as captured what Long called the "graffiti belligerent feeling" of high school.[11] Collages of paint swatches, based on Basquiat's paintings, were correlated to scenes such as "Greased Lightnin'," "Freddy My Love," and the carnival finale (fig. 57).[12] Long then created boards for each scene showing costume sketches, stills from the original film, scenic designer David Korins's renderings of the sets, and paint-color swatches, to ensure that the look of every actor on camera would be part of a cohesive, overall sensibility (fig. 58).

One song in particular encapsulates how Long, and the creative team led by directors Thomas Kail and Alex Rudzinski, made *Grease Live!* a successful and fresh take on this popular material. They reintroduced "Freddy My Love," a song from the 1971 stage production that was not used in the 1978 film, and shot it in a way that spotlights Long's well-known expertise with quick changes. During the girls' slumber party scene at Frenchy's house, Marty sings about the servicemen overseas who are her pen pals, while the other members of their clique, known as the Pink Ladies, sing backup (fig. 60). In one long, continuous take, the actress quick-changes from her robe and negligee into a red, sequined ankle-length gown while stepping through a doorway into a fantasy USO show where she continues singing (fig. 61). At the end of her song, as Marty walks back through the doorway to re-enter Frenchy's bedroom, she once again appears in her negligee. Long achieved this ingenious transformation

by dressing the actress in four layers: the robe that she slips off mid-song; a short blue negligee and long, red dress, which are rigged so that the dress's lower half drops down to ankle length as she slips off the negligee; and finally a second negligee underneath the red dress. "Freddy My Love" thus rejuvenated an otherwise familiar musical with a lesser-known song, while taking full advantage of the hybrid format of the live television special.

57 Collage, "Freddy My Love," *Grease Live!*, 2015. Collage on Bristol board

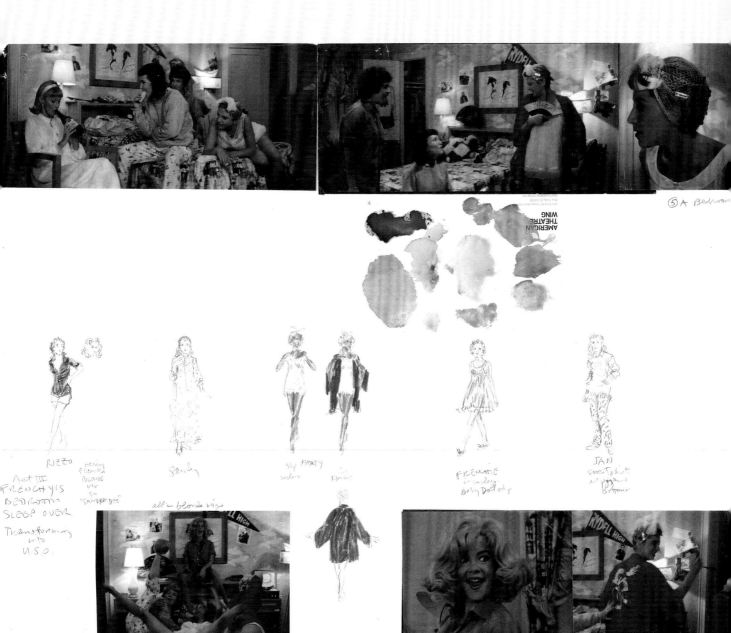

58 Board with
research and sketches
for sleepover at
Frenchy's, *Grease Live!*,
2015. Graphite, colored
pencil, ink, gouache,
watercolor, and collage
on Bristol board

59 Sketch for Danny
Zuko's hair, *Grease
Live!*, 2015. Graphite on
Bristol board

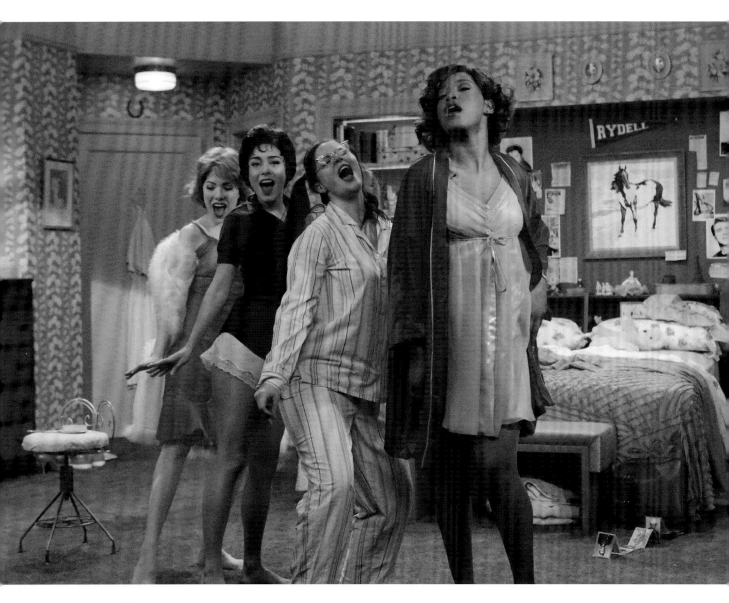

60 Carly Rae Jepsen (Frenchy), Vanessa Hudgens (Betty Rizzo), Kether Donohue (Jan), and Keke Palmer (Marty Maraschino), "Freddy My Love," *Grease Live!*, 2016. Photograph courtesy FOX Broadcast Company

OPPOSITE

61 Carly Rae Jepsen (Frenchy), Vanessa Hudgens (Betty Rizzo), Kether Donohue (Jan), and Keke Palmer (Marty Maraschino), "Freddy My Love," *Grease Live!*, 2016. Photograph courtesy FOX Broadcast Company

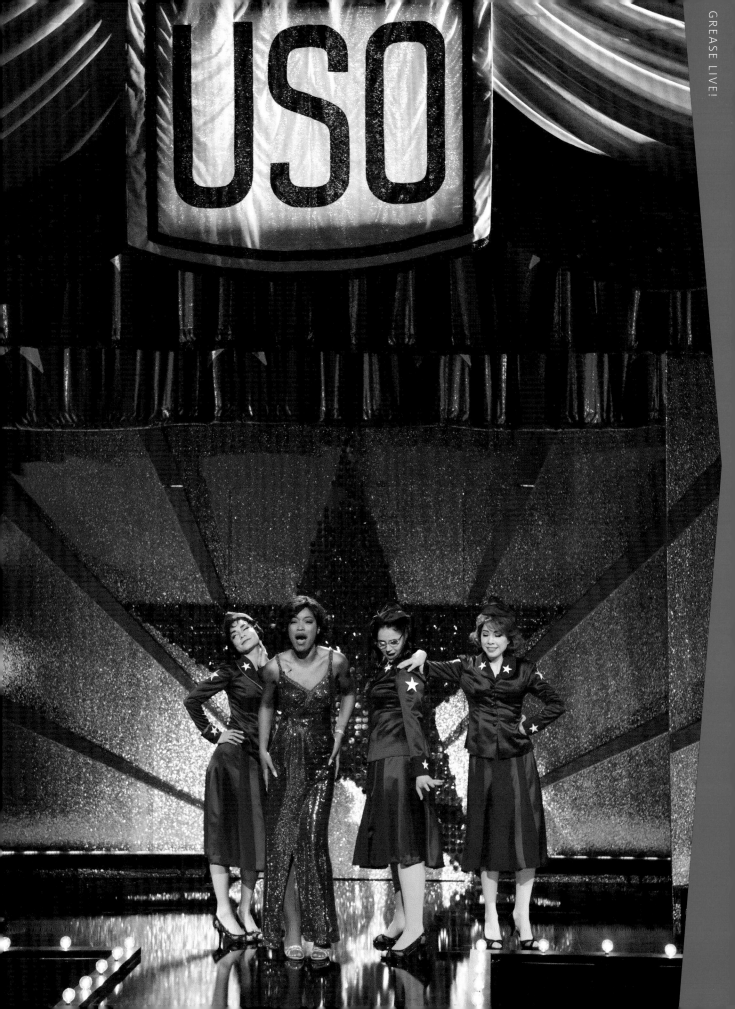

THE ROCKY HORROR PICTURE SHOW:
LET'S DO THE TIME WARP AGAIN

The creators of *The Rocky Horror Picture Show: Let's Do the Time Warp Again*, which aired on television October 20, 2016, faced a thorny dilemma: how to restage an iconic and idolized cult film from 1975, which millions of fans know by heart, in a way that would appeal to existing fans, as well as to a potential new audience (fig. 62).[13] The creative team, led by director Kenny Ortega, approached the project not as a revival, but as a loving tribute to the original, following the film's script and score, but visually reimagining it for the twenty-first century. Because the story features iconic, larger-than-life characters such as the Transylvanians Dr. Frank N. Furter, Riff Raff, and Magenta, and the humans they interact with, Long's ability to define characters through memorable costumes was central to the goals of the project.

The film's focus on the self-described "sweet transvestite, from transsexual, Transylvania," Dr. Frank N. Furter, was problematic in relation to today's world in which LGBT identities are more nuanced and better understood. Critics questioned why the remake was being made at all, and why transgender actress Laverne Cox was cast in a role that was originally defined by a male actor, Tim Curry, who was obviously cross-dressing. For the creators, however, Cox's talents provided the justification for the project and an opportunity for her to redefine the role.[14] Cox has been a fan of the *The Rocky Horror Picture Show* since college, and although the term *transvestite* is no longer appropriate in referring to a transgender person, the film's core message about being true to yourself resonates deeply with her.[15]

With Cox in the lead role, Ortega gave Long the directive that Dr. Frank N. Furter would be "60 percent Grace Jones, 30 percent Tina Turner, and 10 percent Beyoncé."[16] To create Frank's new look, and those of the other characters, the designer's research covered more disparate sources than perhaps any of his other recent projects. Inspiration boards for *The Rocky Horror Picture Show* referenced influences ranging from those that informed the original—science fiction films, especially B movies; old Hollywood glamour; and Norman Rockwell 1950s naïveté for the Brad and Janet characters[17]—to styles and influences from throughout the forty-one years since the film was made—including not only Jones, Turner, and Beyoncé, but also punk rock and the avant-garde fashions of Alexander McQueen (fig. 63).

Long ultimately met the challenge of re-envisioning Dr. Frank N. Furter as a *female* alien mad scientist. Instead of the Dracula-like cape, chest-baring

black half-corset, and fishnets worn by Tim Curry in the role, Long's Frank N. Furter makes her grand entrance in a Grace Jonesesque, flowing, black cape. She also wears a large, disc-shaped headdress, whose form consciously references those of British milliner Philip Treacy, but is adorned with Medusa imagery hand-painted by Long (figs. 64, 65). Upon removing the cape, she reveals a red, sequined, leopard-print, full corset; a cobweb-patterned latex body stocking (a nod to the late glam-rock icon David Bowie and his 1973 cobweb bodysuit); matching red platform shoes; and red bouffant hair (figs. 66, 67). From her first appearance, it is clear that this Frank N. Furter is a different being from her predecessor, though possessed of no less panache.

62 Cast, *The Rocky Horror Picture Show: Let's Do the Time Warp Again*, 2016. Photograph courtesy FOX Broadcast Company

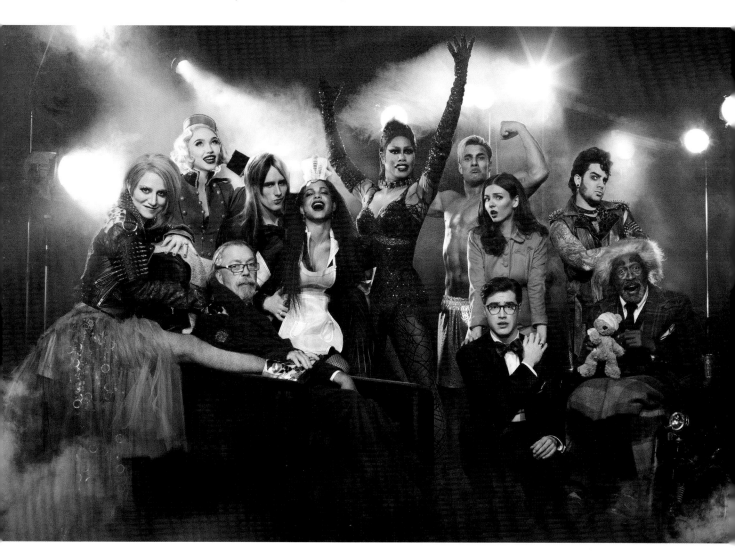

ROCKY HORROR PICTURE SHOW
"reimagined"

Featuring images inspired by:
1). 1930's OLD HOLLYWOOD, GLAMOR.
2). 1970's GLAM ROCK
3). B-HORROR Films/Sci. Fi.
4). 1950's NORMAN ROCKWELL. Naiveté (Brad & Janet)!

DR. Franken Furter.
60% GRACE JONES, 30% TINA TURNER, 10% BEYONCÉ.

TIGHT COLOR SCHEME AT THE CASTLE!
BLACK, WHITE, RED, GOLD, SILVER.
AT THE WEDDING: PASTELS (BRAD & JANET)

MERCHANDISING OPPORTUNITIES:

[This presentation is dedicated to SUE BLANE, MBE, who "imagined the legends"!]

63 Title page for William Ivey Long's design presentation, *The Rocky Horror Picture Show: Let's Do the Time Warp Again*, including notes about Frank N. Furter based on director Kenny Ortega's vision for the character, 2016. Ink, gouache, and watercolor on Bristol board

BELOW
64 Ryan McCartan (Brad Majors), Victoria Justice (Janet Weiss), Laverne Cox (Dr. Frank N. Furter), and Reeve Carney (Riff Raff), "Sweet Transvestite," *The Rocky Horror Picture Show: Let's Do the Time Warp Again*, 2016. Photograph courtesy FOX Broadcast Company

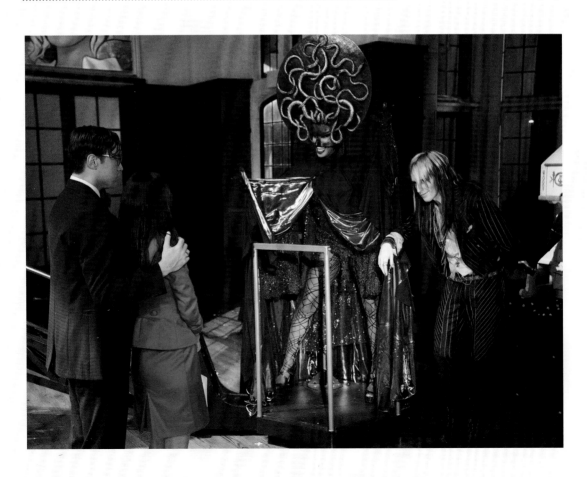

65 Sketch for Laverne Cox as Dr. Frank N. Furter, "Electrical Storm Entrance" scene, *The Rocky Horror Picture Show: Let's Do the Time Warp Again*, 2016. Ink, gouache, and watercolor on Bristol board

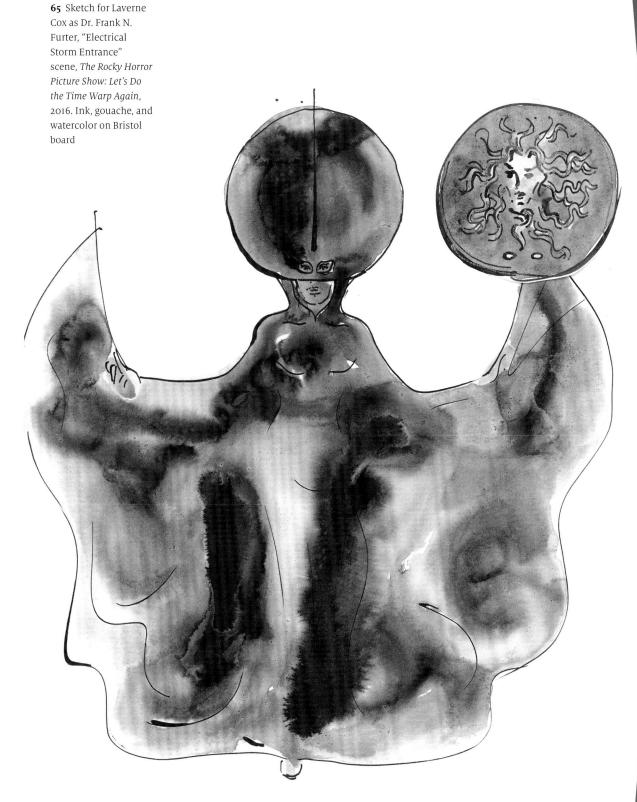

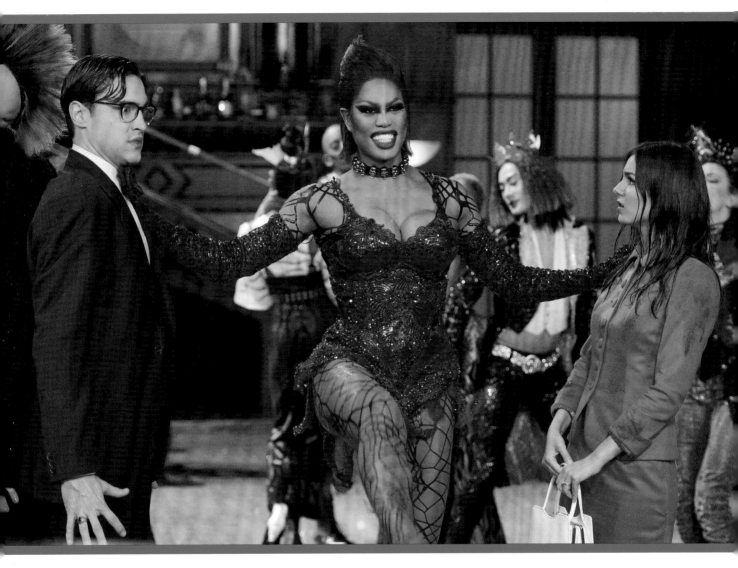

66 Ryan McCartan
(Brad Majors), Laverne
Cox (Dr. Frank N.
Furter), and Victoria
Justice (Janet Weiss),
"Sweet Transvestite,"
*The Rocky Horror
Picture Show: Let's Do
the Time Warp Again*,
2016. Photograph
courtesy FOX
Broadcast Company

OPPOSITE
67 Sketch for Laverne
Cox as Dr. Frank
N. Furter, "Sweet
Transvestite," *The
Rocky Horror Picture
Show: Let's Do the Time
Warp Again*, 2016.
Ink, gouache, and
watercolor on Bristol
board

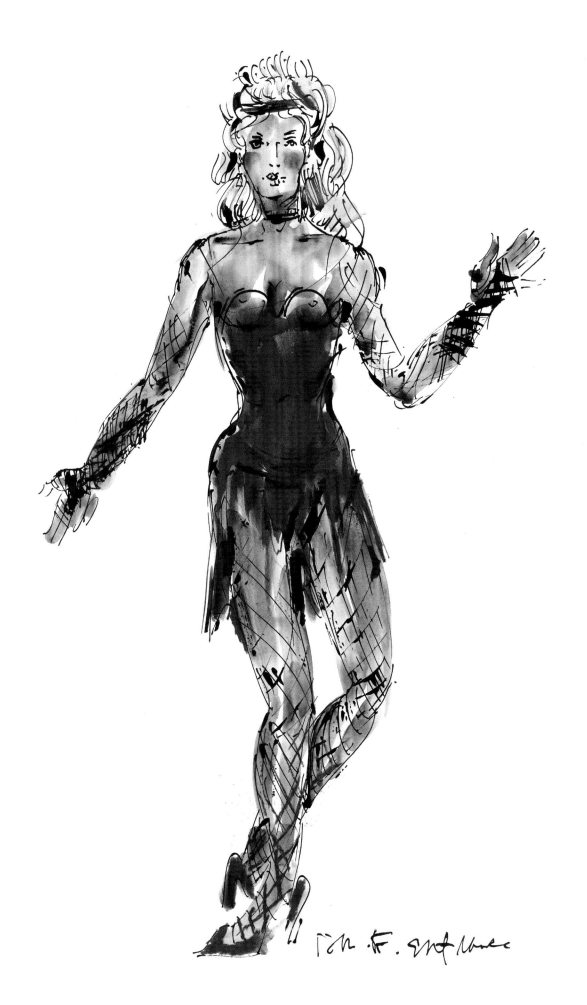

LITTLE DANCER

The original musical *Little Dancer*, produced by the Kennedy Center in 2014, offered rich opportunities for Long to contribute to an entirely new creative product. Portraying the interactions between Edgar Degas and the fourteen-year-old Paris Opera Ballet dancer-in-training Marie van Goethem—the subject of his famous statue the *Petite Danseuse de Quatorze Ans* (1879–81) at the National Gallery of Art—*Little Dancer* was created by director and choreographer Susan Stroman, playwright and lyricist Lynn Ahrens, and composer Stephen Flaherty. To create the characters of Degas and Marie and dramatize the world of the Paris Opera Ballet in the late nineteenth century, the creative team drew upon the history of the sculpture's creation and its showing at the sixth Impressionist exhibition in the spring of 1881, the few known facts about Van Goethem, and especially Degas's numerous paintings and pastel drawings of dancers (fig. 69).[18]

The subject gave Long a wealth of visual reference material. His task was to translate the luminous colors, and sometimes blurrily abstracted lines, of Degas's art into three-dimensional costumes built of real fabric, for real performers to dance in, without losing the magical, glimmering ethereality of Degas's vision of the ballet. Long's immersive research process paid off in the form of beautifully fluent renderings and vibrant ballet costumes. Surrounding himself with inspiration boards of Degas's work, Long channeled the Impressionist artist, incorporating pastels into his sketches for Marie's costumes, as well as those of the other dancers. Of particular note are drawings for the monarch butterfly costumes worn in *Little Dancer*'s opening number, based on several of Degas's works (figs. 70, 71).[19] Long uses ink lines to depict details of the costumes and pastel and colored pencil to suggest Degas's style, striking a balance between the two needs. The play's ballet costumes show the differences in rank between Marie and the top-ranking *étoile*, or star of the ballet, through different levels of ornamentation, as would have been done at the Paris Opera Ballet. The actual costumes, with subtle gradations in the orange and yellow hues on the patterned bodices and in the layers of netting in the tulle skirts, succeed not only at making the dancers resemble butterflies but at evoking Degas's impressionistic ballerina pastels (figs. 72, 73).

Quite different in effect is the costume that perfectly replicates the one worn by the original wax and mixed-media statue in the National Gallery of Art. While Marie's other costumes animate her as a living ballerina, this one returns her to a motionless sculpture (figs. 74, 75). The statue itself is noted for Degas's

inclusion of actual fabrics for the ribbon, bodice, and tutu. Long closely studied the statue and then worked with technicians at the New York costume shop Tricorne, LLC, to craft a gray tutu and bronze-colored bodice, which were then aged with paint and dye to convey their appearance on the statue today (fig. 68). At the musical's end, Marie steps onto a pedestal wearing this costume, adopts the pose of Degas's young dancer, and effectively becomes the statue as modern-day museum visitors gather around her.

68 Costume for Tiler Peck as Marie van Goethem (detail), statue look, *Little Dancer*, 2014. Photograph by Irving Solero

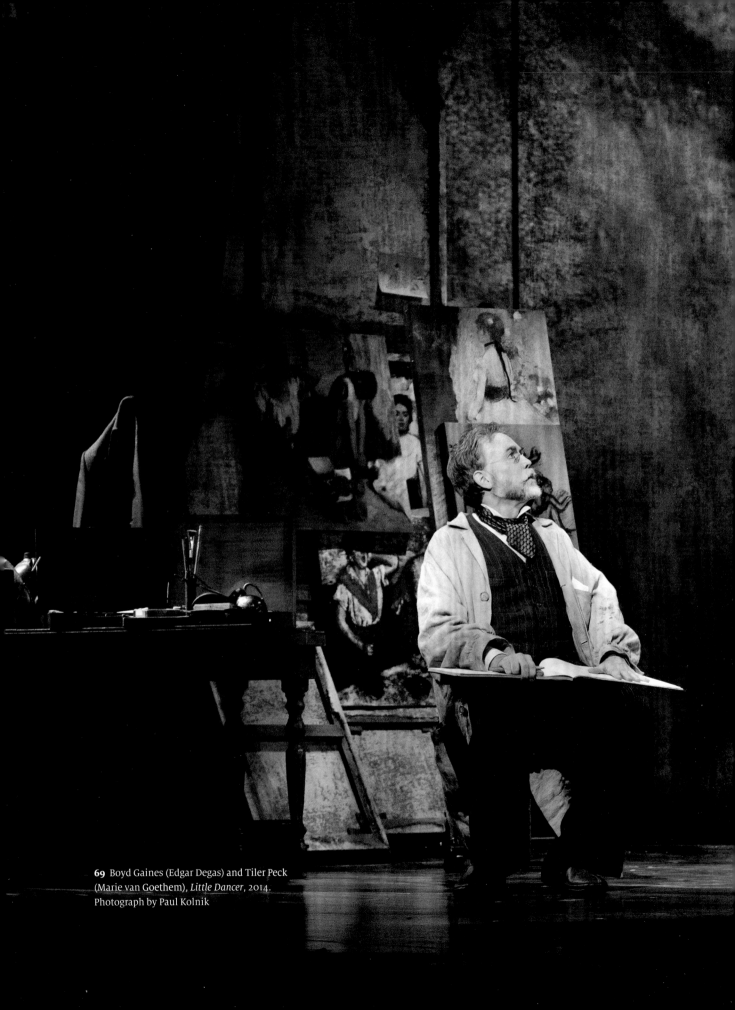

69 Boyd Gaines (Edgar Degas) and Tiler Peck
(Marie van Goethem), *Little Dancer*, 2014.
Photograph by Paul Kolnik

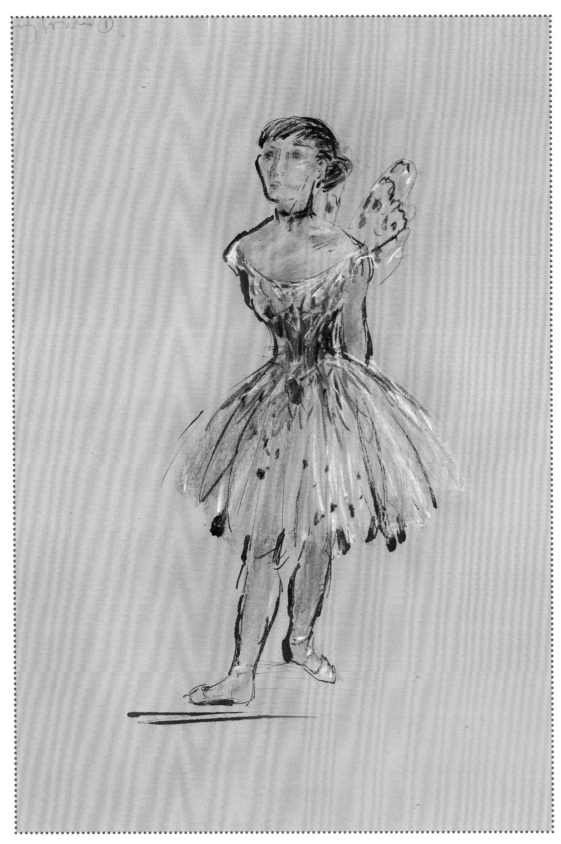

Etoile ①

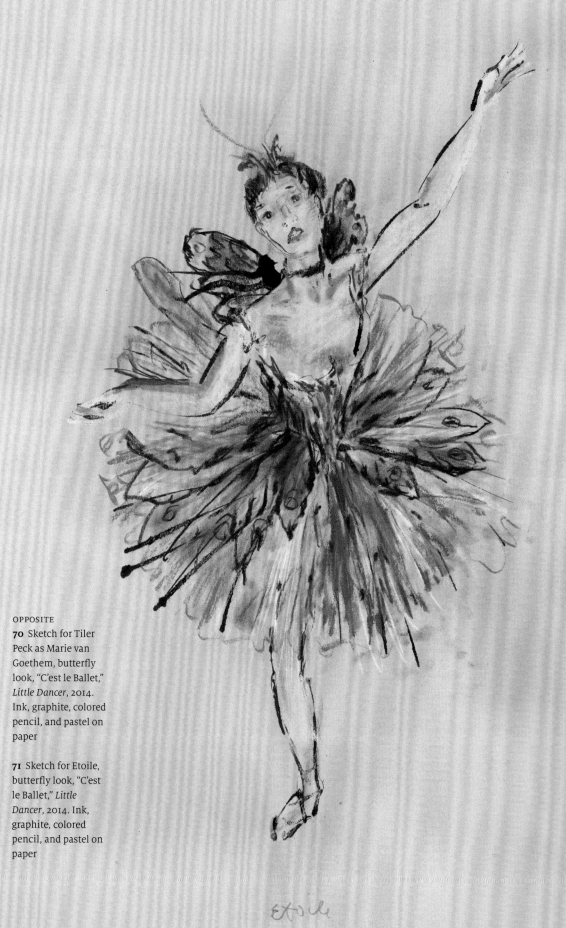

OPPOSITE

70 Sketch for Tiler Peck as Marie van Goethem, butterfly look, "C'est le Ballet," *Little Dancer*, 2014. Ink, graphite, colored pencil, and pastel on paper

71 Sketch for Etoile, butterfly look, "C'est le Ballet," *Little Dancer*, 2014. Ink, graphite, colored pencil, and pastel on paper

Etoile

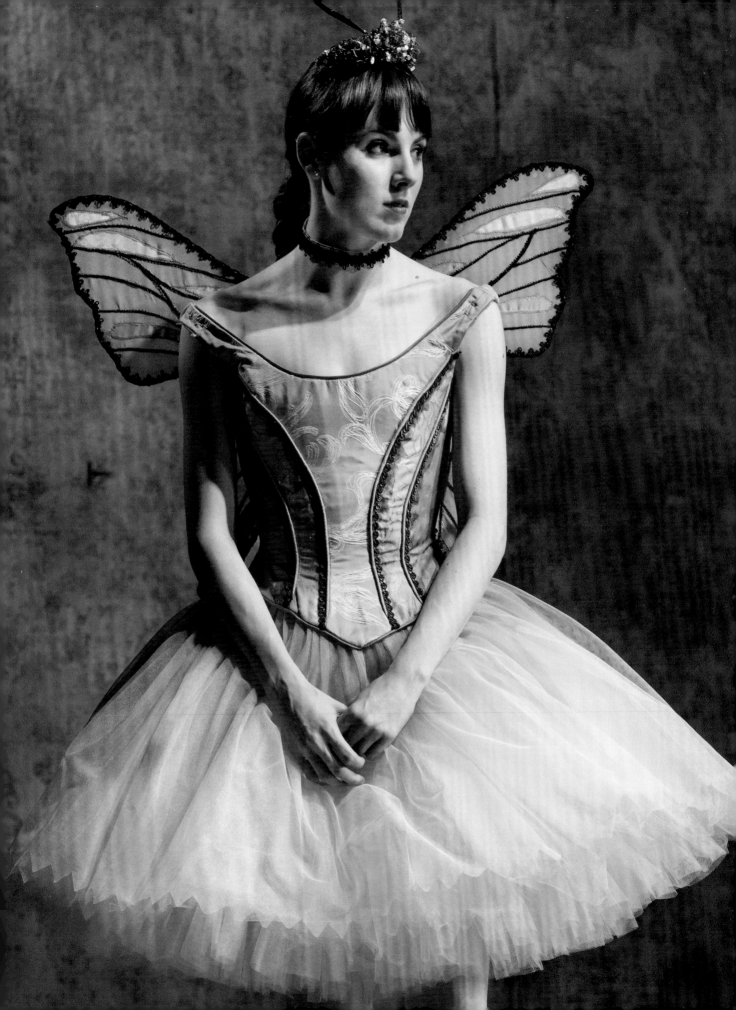

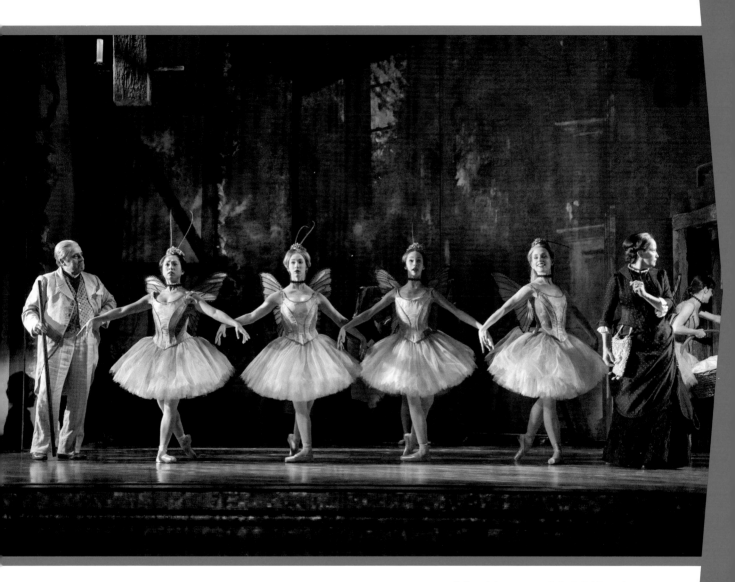

OPPOSITE
72 Tiler Peck (Marie
van Goethem),
Little Dancer, 2014.
Photograph by Paul
Kolnik

73 Left to right:
Michael McCormick
(Corbeil), Jolina
Javier (Nicoline),
Katelyn Prominski
(Etoile), Lyrica
Woodruff (Chantal),

Polly Baird (Esme),
Michele Ragusa
(Mme Theodore),
and Tiler Peck (Marie
van Goethem),
Little Dancer, 2014.
Photograph by
Paul Kolnik

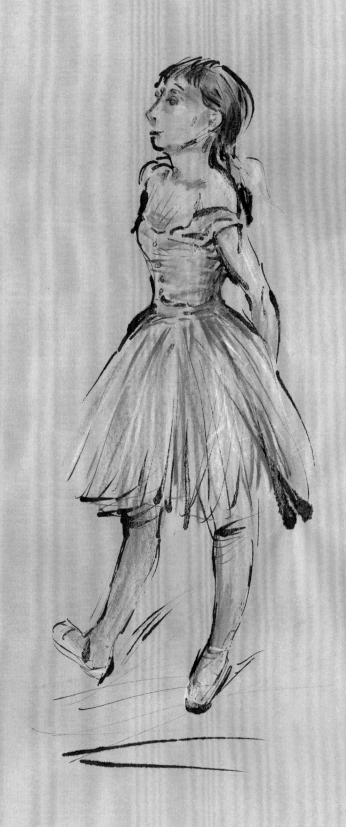

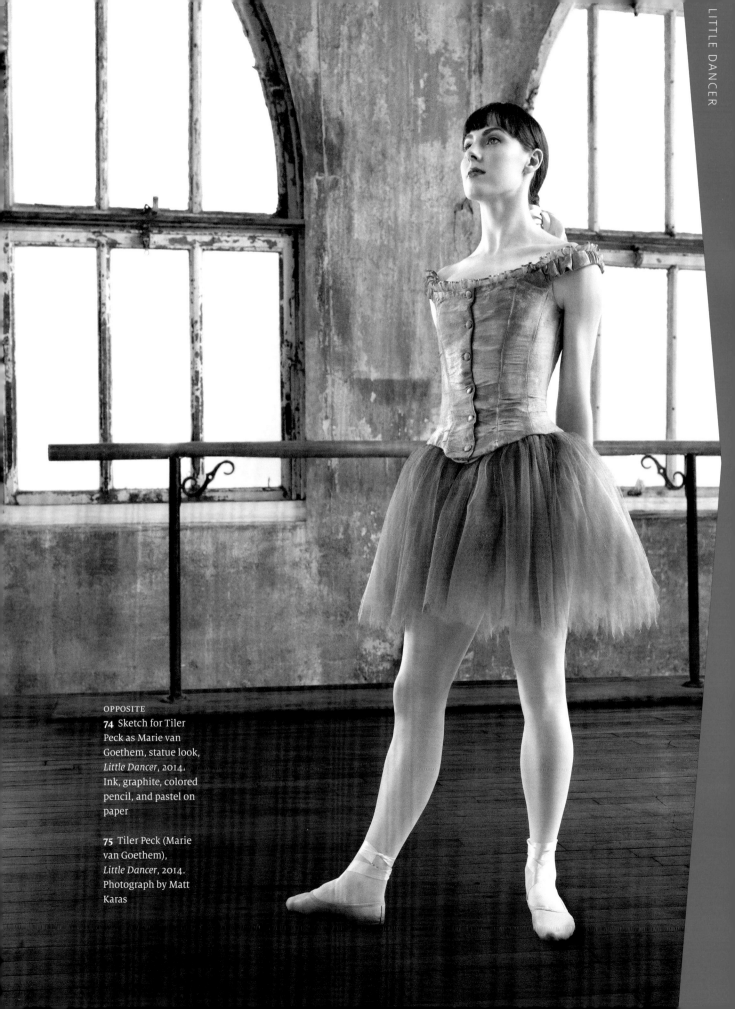

OPPOSITE

74 Sketch for Tiler Peck as Marie van Goethem, statue look, *Little Dancer*, 2014. Ink, graphite, colored pencil, and pastel on paper

75 Tiler Peck (Marie van Goethem), *Little Dancer*, 2014. Photograph by Matt Karas

RODGERS AND HAMMERSTEIN'S CINDERELLA

Perhaps the consummate example of Long's many talents among all of his projects since 2007 is *Rodgers and Hammerstein's Cinderella*, produced in 2013, for which he won his sixth Tony Award. The show blends music written in 1957 with a new script by Douglas Carter Beane that develops and modernizes Cinderella, the Prince, and other characters from the Brothers Grimm's famous story. Though this new Cinderella is more of a modern woman, the story is still a fairy tale that takes place "long ago and far away." The fairy tale premise gave Long and the creative team license to explore a wide variety of stylistic influences. Director Mark Brokaw and scenic designer Anna Louizos set the story in a nondescript European kingdom in a forest; Long built off this idea by consulting imagery of the natural world—butterflies, moths, birds, woodland animals, and of course, trees and wood. For the peasants, he looked at the paintings of Dutch artist Pieter Bruegel the Elder (1525–1569), and for Cinderella's everyday dress, an eighteenth-century ceramic figurine of a milkmaid (fig. 83).[20] His visual research also included Renaissance suits of armor; the horse sculptures of American artist Deborah Butterfield (b. 1949); portraits by the Italian painter Giuseppe Arcimboldo (1526–1593) composed of fruits and vegetables; and contemporary couture ball gowns, among other far-ranging sources.

The sketches and costumes that blossomed forth from the designer's immersion into this fairy tale world are every bit as magical as the story requires. Cinderella is known for her grace and kindness; her earthy green and brown peasant dress and her sparkling white ball gown are both suitably graceful and elegant (fig. 76). Likewise, Long's rendering of the Prince and Cinderella at the ball conveys the majesty of the future king and queen, and his detail studies of Cinderella's ball gown resemble Old Master drawings (figs. 77–79). The Fairy Godmother receives equally thoughtful treatment, appearing like a delicate butterfly, her gown a swirl of supernatural energy (fig. 80).

The ball where Cinderella and the Prince fall in love is a pivotal moment in the story, and Long's costumes are essential to creating the atmosphere of romance. The gentlemen wear long formal jackets in pale green with swallowtail hems, in keeping with the forest imagery, while the women wear voluminous gowns in soft, yet vibrant colors intended to evoke butterflies and flowers (fig. 81). The costumes are striking on first sight, but their full beauty is not apparent until Cinderella enters the ball, catches the Prince's attention, and changes the tone. As they sing about falling in love, Cinderella, the Prince, and all of the ensemble members dance a graceful waltz in which the female dancers are

lifted and twirled, revealing layers of glistening, gauzy petticoats woven with sparkling metallic threads. Amidst the whirl of color, Cinderella and the Prince stand out in their white formal wear. It is as if suddenly everyone is in love, with their heads in the clouds.

The most remarkable scenes of the musical are the transformations that happen in full view of the audience, due entirely to Long's ingenious costume designs and the actresses' skills in manipulating them. The character of Marie is an older woman who befriends Cinderella. Early in the show, Long garbs Marie in a brown, ragged cloak that she later casts off to reveal that she is actually the Fairy Godmother, now wearing a shimmering pink gown with panniers and a tiara resembling antennae. As her cloak disappears beneath her skirts, the panniers pop up and the antennae emerge. This change to her entire silhouette emphasizes the character's transformation. Next, it is Cinderella's turn to transform in an ingenious, two-step, yet split second, maneuver. First, as she spins around, her kerchief and peasant dress fall away to reveal a white dress with poufed sleeves and an elegant up-do and tiara on her head. Then, almost imperceptibly to the audience, she takes hold of a bell-shaped skirt, which has been cleverly hidden in plain sight onstage, and puts it on to complete her finery for the ball. It is one of Long's most masterful costume manipulations (fig. 82). All of these changes are made possible by the designer's knowledge of costume construction, and by his collaboration with the drapers and the actresses to develop the intricate rigging necessary to conceal nearly an entire change of clothing inside one garment.

...................

The range of William Ivey Long's projects over the last ten years—from an outdoor drama with hundreds of costumes that must be read visually from far away, to musicals performed in theaters, to television specials where the costumes are seen in close-ups—reflects his diverse talents. These shows vary in setting from the late 1500s to an unspecified date that resembles 1970s America, and include retellings of historical events, a murder mystery, two musical love stories, and a work of science fiction. Long's ability to intimately understand the needs of each project, particularly directors' and actors' ideas about characters, and give tangible form to these concepts, are why he remains one of Broadway's most celebrated costume designers.

OPPOSITE
78 Sketch for
Ella, "Ten Minutes
Ago," *Rodgers and
Hammerstein's
Cinderella*, 2012.
Gouache, watercolor,
colored pencil, and
bleach on paper

RIGHT
76 Sketch for Ella, "In
My Own Little Corner"
(left) and "Ten Minutes
Ago" (right), *Rodgers
and Hammerstein's
Cinderella*, 2012. Ink,
gouache, watercolor,
bleach, and glitter glue
on paper

BELOW
77 Sketch for Prince
Topher and Ella, "Ten
Minutes Ago," *Rodgers
and Hammerstein's
Cinderella*, 2012. Ink,
gouache, watercolor,
bleach, and glitter glue
on paper

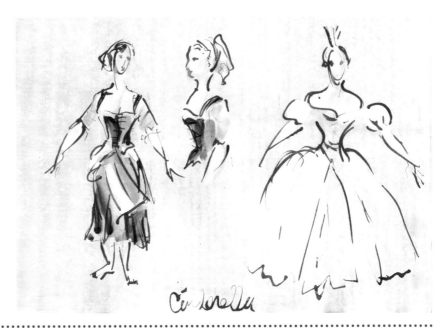

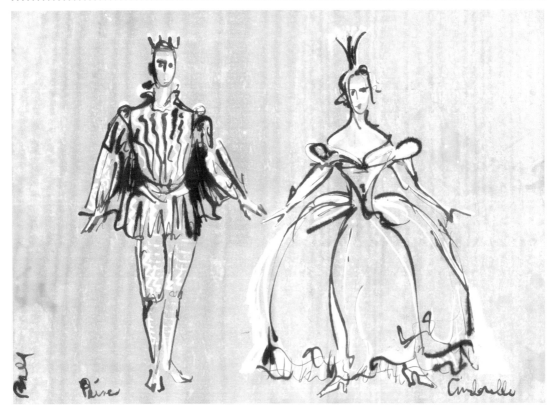

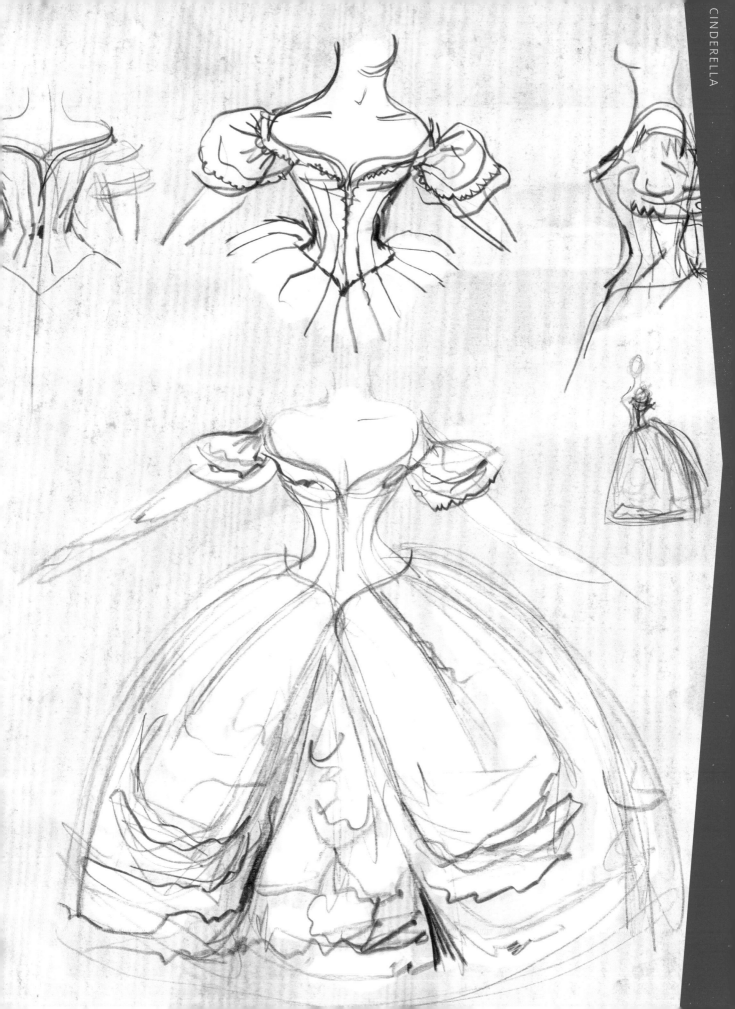

OPPOSITE

79 Sketch for Ella, "Ten Minutes Ago," *Rodgers and Hammerstein's Cinderella*, 2012. Gouache, watercolor, and colored pencil on paper

80 Sketch for Fairy Godmother, "Impossible/It's Possible," *Rodgers and Hammerstein's Cinderella*, 2012. Gouache, watercolor, ink, and bleach on paper

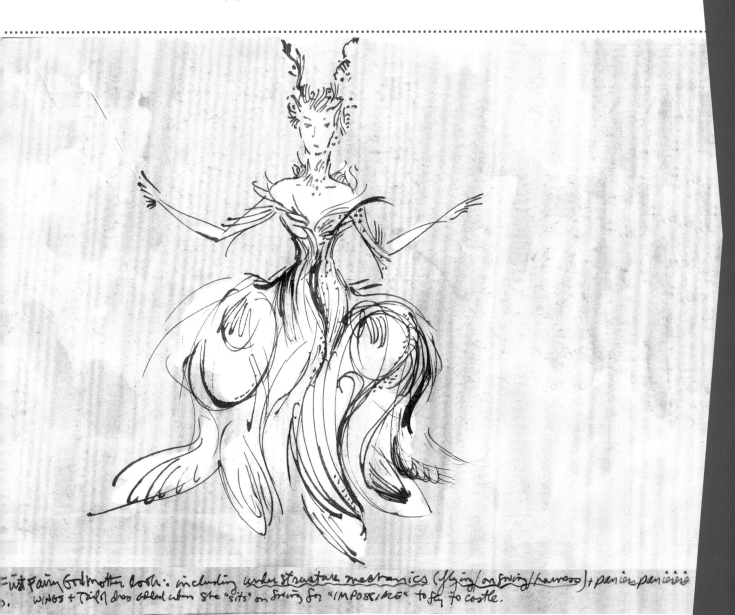

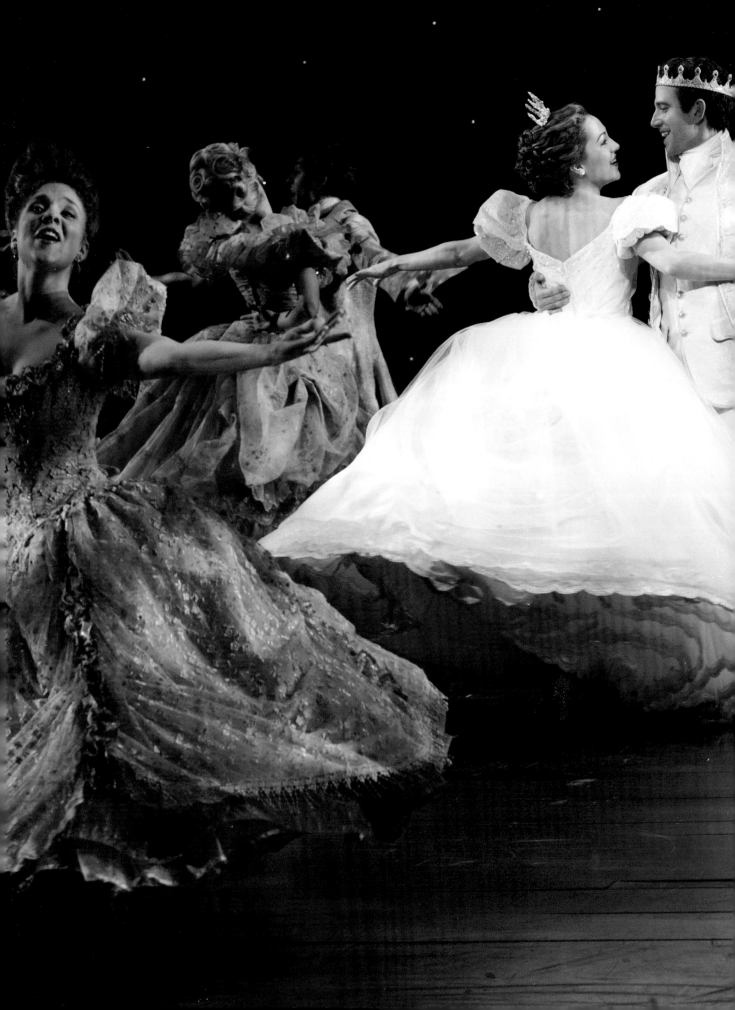

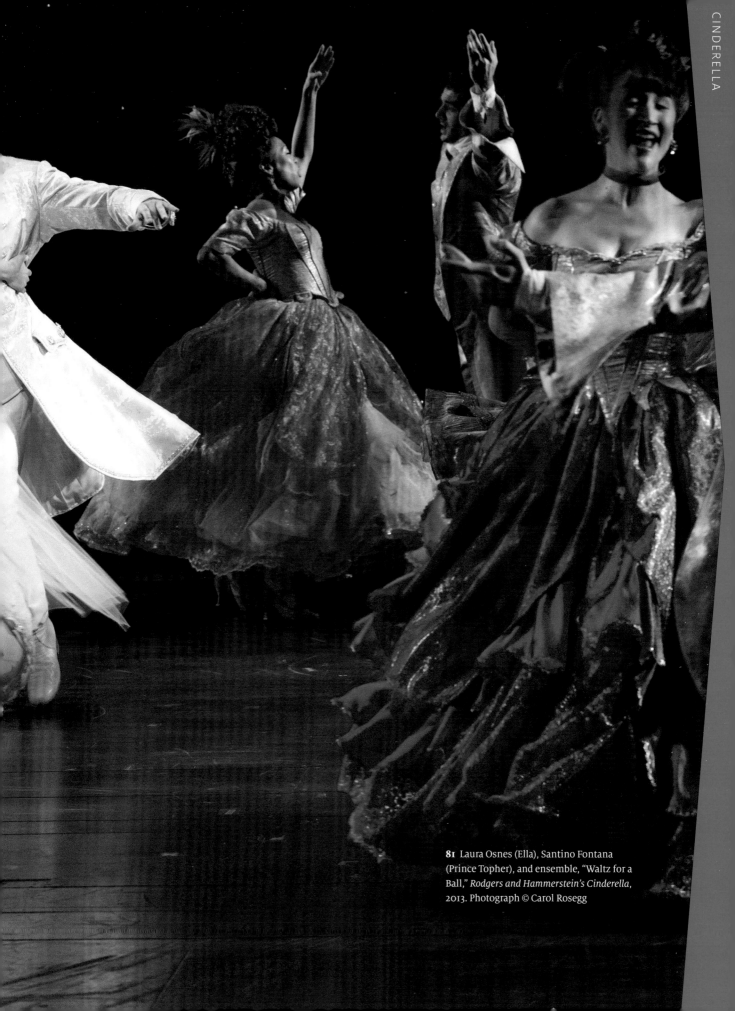

81 Laura Osnes (Ella), Santino Fontana (Prince Topher), and ensemble, "Waltz for a Ball," *Rodgers and Hammerstein's Cinderella*, 2013. Photograph © Carol Rosegg

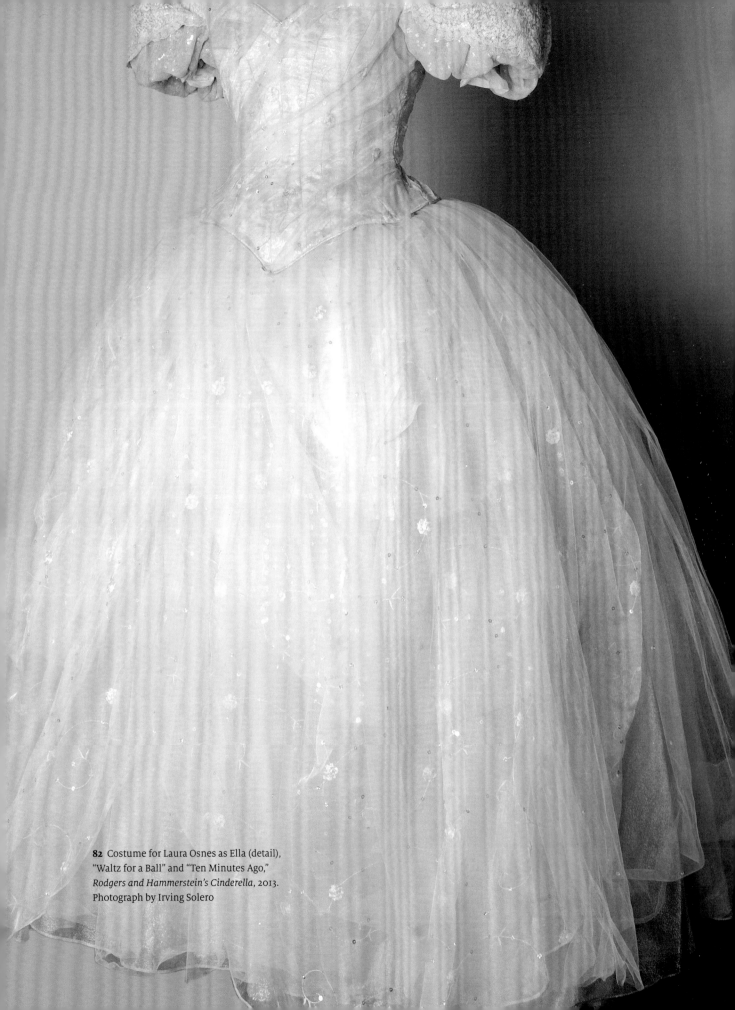

82 Costume for Laura Osnes as Ella (detail),
"Waltz for a Ball" and "Ten Minutes Ago,"
Rodgers and Hammerstein's Cinderella, 2013.
Photograph by Irving Solero

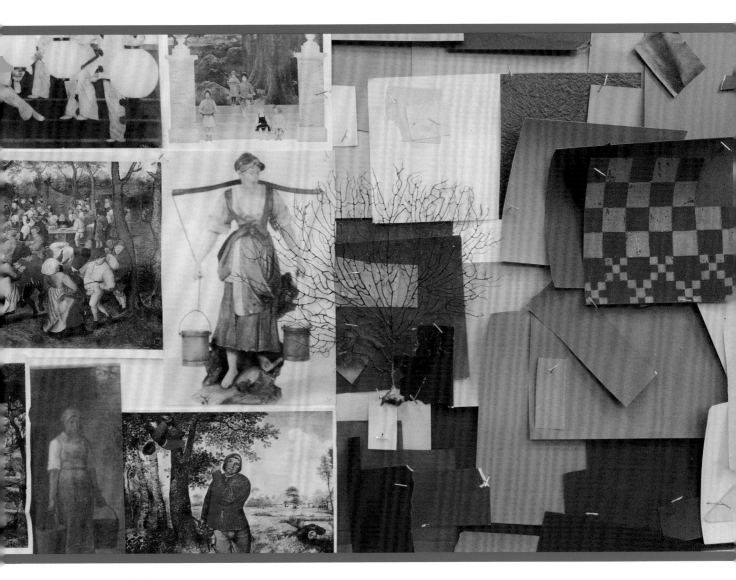

83 Inspiration board
(detail), for *Rodgers
and Hammerstein's
Cinderella*, 2012.
Collage on kraft paper.
Photograph by Irving
Solero

NOTES

1. William Ivey Long is notoriously prolific; his output is made possible by his full-time studio staff of Brian Mear, Donald Sanders, and occasional interns, as well as associate costume designers who freelance on specific productions. Mear and Sanders run the day-to-day activities of the studio, hold myriad responsibilities in bringing Long's ideas to fruition, and maintain his calendar and archive. They were essential to the process of organizing the Mint Museum's exhibition and researching this essay. I cannot thank them enough, especially Mear, for sharing Long's research materials, answering my many questions about his process, and helping with other aspects of this project.

2. Long designed the costumes for the 1998 revival of *Cabaret* by Roundabout Theatre Company; the company relaunched it in 2014 with the same designs.

3. In 2007, the Cameron Art Museum honored Long with a retrospective featuring his work from 1982 to 2007. See Polly Koch, Don Quaintance, and Deborah Velders, eds., *Between Taste and Travesty: Costume Designs by William Ivey Long* (Wilmington, NC: Cameron Art Museum, 2007).

4. Fortunately, at the time of the fire no one was injured and the production had already closed for the season. Some costumes survived that were at the dry cleaner or on view at museums, but they were in worn condition, having had several years' exposure to the elements. See Catherine Kozak, "Fire Destroys Costumes at 'Lost Colony,'" *The Virginian-Pilot*, September 11, 2007, http://pilotonline.com/news/fire-destroys-costumes-at-lost-colony/article_d28a9665-976f-56bd-abc6-7e8d68151727.html, and Associated Press, "After Devastating Fire, 'The Lost Colony' Returns," *Times-News*, May 31, 2008, http://www.blueridgenow.com/article/NC/20080531/News/606047520/HT/.

5. Prior to 2007, Long had returned to the production as costume designer in 1987 and as scenic designer in 1988, bringing to bear his deep understanding of history and dramaturgy. As costume and scenery components wore out and needed to be replaced, he redesigned them to be more historically accurate. Yet, because of limited funding, materials could only be replaced in a piecemeal fashion until the fire. Brian Mear, conversation with author, January 23, 2017.

6. Brian Mear, conversation with author, January 23, 2017.

7. For a description of this process and the roles of costume technicians see Rosemary Ingham and Liz Covey, *The Costume Designer's Handbook*, 2nd ed. (Portsmouth, New Hampshire: Heinemann Educational Books, Inc., 1992), 165–73.

8. Roundabout Theatre Company, *Upstage*, guide for *The Mystery of Edwin Drood*, 2012, 6, http://www.roundabouttheatre.org/Roundabout/media/Roundabout/PDF/UPSTAGE/Drood_Upstage2.pdf.

9. Brian Mear, conversation and e-mail message with author, January 23, 2017.

10. *"On The Twentieth Century*—William Ivey Long's Costume Design," YouTube video, 2:26, posted by Roundabout Theatre Company, April 2, 2015, https://www.youtube.com/watch?v=t6PctjOxj_g.

11. Ruthie Fierberg, "Those Magic Changes: William Ivey Long's 'Today Take' on the Look and Costumes of *Grease: Live*," January 31, 2016, *Playbill*, http://www.playbill.com/article/those-magic-changes-william-ivey-longs-today-take-on-the-look-and-costumes-of-grease-live-com-382855.

12. Ibid.

13. *The Rocky Horror Picture Show* is the longest-running film in history, having played continuously in theaters since 1975.

14. Dave Itzkoff, "'Rocky Horror' Remake: Is It Time to Go Back to Camp?," *The New York Times*, October 11, 2016, https://www.nytimes.com/2016/10/16/arts/television/rocky-horror-picture-show-remake-fox-laverne-cox.html?_r=0.

15. See Itzkoff, "'Rocky Horror' Remake"; Ryan McPhee, "Laverne Cox on Finding Her Voice for *Rocky Horror Picture Show* and Her Dream Stage Roles," Broadway.com, October 10, 2016, http://www.broadway.com/buzz/186277/laverne-cox-on-finding-her-voice-for-the-rocky-horror-picture-show-her-dream-stage-roles; and Benjamin Lindsay, "Laverne Cox is Ready to Get Sexy as *Rocky Horror*'s Notorious Dr. Frank N. Furter," *Vanity Fair*, October 13, 2016, http://www.vanityfair.com/hollywood/2016/10/rocky-horror-laverne-cox-sweet-transvestite.

16. Ruthie Fierberg, "Exclusive: A Sneak Peek at the Costumes for Fox's *Rocky Horror*," *Playbill*, October 11, 2016, http://www.playbill.com/article/exclusive-a-sneak-peek-at-the-costumes-for-foxs-rocky-horror.

17. Like Rosa Bud in *The Mystery of Edwin Drood*, Brad and Janet wear "victim blue." However, it is a darker shade that complements the actors' coloring and the other colors in the scenes in which they appear. It may also communicate that although Brad and Janet seem like victims in their first scenes at the castle, they soon become more empowered and self-directed.

18. The musical also portrays Marie's life of poverty outside the ballet rehearsal room, including her mother's work as a laundress and her older sister's situation as a kept woman. The creative team drew upon Degas's depictions of laundresses, absinthe drinkers, cafe patrons, etc. for these aspects. Most of the non-ballet costumes were rented, either from Long's archive or other sources.

19. Among these are *Dancers in the Wings* (ca. 1876–78), in the collection of the Norton Simon Museum, Pasadena, California; and *Bowing Dancers* (1885), in a private collection.

PRODUCTION CREDITS
Credits list only fabricators of costumes illustrated in this book, not all costumes in a particular production

NINE (1982)
46th Street Theatre

Book by Arthur Kopit
Music and lyrics by Maury Yeston, adapted from the Italian by Mario Fratti
Directed by Tommy Tune
Choreographed by Thommie Walsh
Scenic design by Lawrence Miller
Costume design by William Ivey Long

Costume fabricated by Werner Kulovits, Barbara Matera, Ltd. (Carla)

GUYS AND DOLLS (1992 revival)
Martin Beck Theatre

Book by Jo Swerling and Abe Burrows
Based on a story and characters by Damon Runyon
Music and lyrics by Frank Loesser
Directed by Jerry Zaks
Choreographed by Christopher Chadman
Scenic design by Tony Walton
Costume design by William Ivey Long

Costumes fabricated by Vincent Zullo, Vincent Costumes, Inc.

CONTACT (2000)
Vivian Beaumont Theater

Conceived by Susan Stroman and John Weidman
Book by John Weidman
Directed by Susan Stroman
Choreographed by Susan Stroman
Scenic design by Thomas Lynch
Costume design by William Ivey Long

Costumes fabricated by Jen King (Girl in the Yellow Dress) and Scafati Tailoring, Inc. (Joe)

THE PRODUCERS (2001)
St. James Theatre

Book by Mel Brooks and Thomas Meehan
Music and lyrics by Mel Brooks
Directed by Susan Stroman
Choreographed by Susan Stroman
Scenic design by Robin Wagner
Costume design by William Ivey Long

Costume fabricated by Janet Bloor, Euroco Costumes, Inc., with beading by Bessie Nelson (Roger De Bris)
Millinery fabricated by Rodney Gordon

HAIRSPRAY (2002)
Neil Simon Theatre

Book by Mark O'Donnell and Thomas Meehan
Music by Marc Shaiman, lyrics by Scott Wittman and Marc Shaiman
Based on the film written and directed by John Waters
Directed by Jack O'Brien
Choreographed by Jerry Mitchell
Scenic design by David Rockwell
Costume design by William Ivey Long

Costumes fabricated by Werner Kulovits and Janet Bloor, Euroco Costumes, Inc.; custom feathers by Jon Coles at American Plume & Fancy Feather, Inc.; shoes by T. O. Dey Custom Made Shoes (Tracy Turnblad and Edna Turnblad)
Wigs fabricated by Paul Huntley

THE LOST COLONY (2008)
Waterside Theatre, Manteo, North Carolina

Book by Paul Green
Directed by Robert Richmond
Choreographed by Mira Kingsley
Scenic design by William Ivey Long
Costume design by William Ivey Long

Costumes fabricated by Jennifer Love Costumes, Inc. (Arthur Barlow, Governor John White); Werner Kulovits, Euroco Costumes, Inc. (Eleanor White); Maggie Frede, Tricorne, LLC (Sir Walter Raleigh); Triffin Norris, Tricorne, LLC (Captain Ananias Dare); Hugh Hanson, Carelli Costumes, Inc. (Queen Elizabeth I and courtiers); Schneeman Studios, Ltd. (Chief Manteo, queen's master of ceremonies, queen's pages); Timberlake Studios, Inc. (red soldiers); Robyn Coffey and Jen King (Native Americans other than Manteo); and Donna Langman (Philip Amadas)
Millinery by Ignatius Hats (Captain Ananias Dare, Sir Walter Raleigh, and Governor John White) and Carelli Costumes, Inc. (Queen Elizabeth I's courtiers)
Jewelry and crown by Larry Vrba (Queen Elizabeth I)

Armor by Armor Venue
Wig fabricated by Paul Huntley (Queen Elizabeth I)

THE MYSTERY OF EDWIN DROOD (2012 revival)
Roundabout Theatre Company/Studio 54

Book by Rupert Holmes
Music and lyrics by Rupert Holmes
Directed by Scott Ellis
Choreographed by Warren Carlyle
Scenic design by Anna Louizos
Costume design by William Ivey Long

Costumes fabricated by Jennifer Love Costumes, Inc. (Edwin Drood, John Jasper, Neville Landless, The Reverend Mr. Crisparkle, and others); Werner Kulovits, Euroco Costumes, Inc. (The Princess Puffer and others); Katherine Marshall, Tricorne, LLC (Rosa Bud, Helena

Landless, and others);
Barbara Matera, Ltd. (bodice for Helena Landless);
and The Chester Costume Company, Inc. (various)
Millinery fabricated by Rodney Gordon
Wigs fabricated by Paul Huntley

RODGERS AND HAMMERSTEIN'S CINDERELLA (2013)
Broadway Theatre

Original book by Oscar Hammerstein II, new
book by Douglas Carter Beane
Music by Richard Rodgers, lyrics by
Oscar Hammerstein II
Directed by Mark Brokaw
Choreographed by Josh Rhodes
Scenic design by Anna Louizos
Costume design by William Ivey Long

Costumes fabricated by Carelli Costumes, Inc.
(Prince Topher and ensemble armor); Werner Kulovits,
Euroco Costumes, Inc. (Sebastian); Jennifer Love
Costumes, Inc. (Prince Topher and male ensemble);
Tricorne, LLC (Cinderella and female ensemble); and
Parsons-Meares, Ltd. (Marie)
Crowns and millinery fabricated by Rodney Gordon
(Prince Topher and Cinderella)
Tiaras and jewelry by Larry Vrba (Cinderella and Marie)
Wigs fabricated by Paul Huntley

LITTLE DANCER (2014)
The Kennedy Center/Eisenhower Theater

Music and lyrics by Lynn Ahrens and Stephen Flaherty
Directed by Susan Stroman
Choreographed by Susan Stroman
Scenic design by Beowulf Boritt
Costume design by William Ivey Long

Costumes fabricated by Halsey Onstage, LLC (Algerian
and butterfly costumes for Marie and ensemble);
Tricorne, LLC (Little Dancer Aged Fourteen costume);
Jeff Fender Studio (aging for Little Dancer Aged Fourteen
costume); Schneeman Studio, Ltd. (cancan costumes
and Mary Cassatt); Timberlake Studios, Inc. (Degas's
smock); The Chester Costume Company, Inc. (adult
Marie, Degas, and ensemble members); Goodspeed
Opera House (adult Marie, Degas, and ensemble
members); Miodrag Gubernic (wings and headpieces
for butterfly costumes); and Alexa Cach (headpieces
for butterfly costumes)
Wigs fabricated by Paul Huntley

ON THE TWENTIETH CENTURY (2015 revival)
Roundabout Theatre Company/American Airlines
Theatre

Book and lyrics by Betty Comden and Adolph Green
Music by Cy Coleman
Directed by Scott Ellis
Choreographed by Warren Carlyle
Scenic design by David Rockwell
Costume design by William Ivey Long

Costumes fabricated by Artur and Tailors, Ltd.
(Oscar Jaffee and Owen O'Malley); Giliberto Designs,
Inc. (Oliver Webb and Bruce Granit); Tricorne, LLC (Lily
Garland); Schneeman Studios, Ltd. (Letitia Peabody
Primrose and female ensemble); and Jennifer Love
Costumes, Inc. (male ensemble)
Millinery fabricated by Rodney Gordon
Wigs fabricated by Paul Huntley

GREASE LIVE! (2016 revival)
Aired on Fox, January 31, 2016

Original book, music, and lyrics by Jim Jacobs
and Warren Casey
Book adapted for television by Robert Cary
and Jonathan Tolins
Directed by Thomas Kail and Alex Rudzinski
Choreographed by Zachary Woodlee
Scenic design by David Korins
Costume design by William Ivey Long

Costumes fabricated by Muto-Little (transforming
negligee for Marty and transforming jumpsuits for
T-Birds) and Fox Studios, Inc.
Hair and wigs by Mary Guerro

THE ROCKY HORROR PICTURE SHOW: LET'S DO THE TIME WARP AGAIN (2016 revival)
Aired on Fox, October 20, 2016

Book, music, and lyrics by Richard O'Brien
Original screenplay by Jim Sharman
Directed and choreographed by Kenny Ortega
Scenic design by Peter Cosco
Costume design by William Ivey Long

Costumes fabricated by Seamless Costumes, Ltd.,
Northbound Leather, Elastica Engineering (latex stock-
ings and shrug for Dr. Frank N. Furter), and Fox Studios,
Inc.; shoes by Jitterbug Boy. Millinery by Lilliput Hats
and David Dunkley
Wigs by Debra Johnson

THE OPEN DOOR (2017)
Premiere, Veterans Memorial Auditorium, Providence,
Rhode Island, February 3, 2017

Music: *Enigma Variations* by Edward Elgar
Choreographed by Paul Taylor
Paul Taylor Dance Company
Scenic design by William Ivey Long
Costume design by William Ivey Long

Costumes fabricated by Schneeman Studios, Ltd.

PHOTOGRAPHY CREDITS
Unless otherwise noted in captions, all photographs
are courtesy William Ivey Long Studios

Acknowledgments

The creation of this book—from initial thoughts about content and design, through the research and writing phase, into the laborious, multilayered, and lengthy process of securing the visual components—required the knowledge and talent of many individuals. First among them is the man himself, William Ivey Long. His belief in the Mint's ability to achieve the highest level of excellence in telling the story of his recent projects in an intellectually strong and aesthetically appealing book drove the very best work captured between these pages. Second is Brian Mear, vice president, William Ivey Long Studios, Inc., who worked with us on a near daily basis, answering hundreds of questions, verifying countless facts, and providing introductions to many actors, agencies, and image sources. Quick to respond to looming deadlines, and changes to "the plan," he was ever calm when matters became challenging. And third is Donald Sanders, vice president, William Ivey Long Studios, Inc., who assisted in countless ways, keeping the project on track.

The scholarly contribution *William Ivey Long: Costume Designs 2007–2016* makes is due to the blending of three distinct yet interconnected texts. My introductory essay questions the often-held notion that costume design is subservient to fashion design, through a concise historical perspective, with much sensitivity to Long's oeuvre. Peter Marks provides a critical assessment of William's work over the course of his career. Rebecca E. Elliot has written the substantive text of the book, capturing the salient details of Long's design process within the context of the theatrical productions, grounded in a profound understanding of his craft. With the utmost enthusiasm for this project, she dedicates her essay to Ann K. Elliot and, in memoriam, to Jeremy F. Elliot (who took Rebecca and her sister to New York for the first time, as teenagers in the early 1990s, where they saw *Guys and Dolls*, for which William Ivey Long designed the costumes—a fact whose significance she would only understand twenty years later).

Colleagues and friends across the country who helped with research and the preparation of the manuscript include Jennifer L. Bach, costume shop supervisor, Utah Shakespeare Festival, and Lauren D. Whitley, senior curator, Museum of Fine Arts, Boston. At the Mint Museum, Kathleen V. Jameson, president & CEO, had the brilliance of mind to recognize costume design as a valuable subject of art historical inquiry, and the work of William Ivey Long as exemplary; Leslie Cone, assistant registrar, rights & reproductions, managed the Herculean task of securing image permissions from a plethora of sources,

many of which were elusive; Michele Leopold, director of collections & exhibitions, HannaH Crowell, exhibition designer, Joyce Weaver, director of library & archives, and Hillary Cooper, director of advancement & communications, provided valuable advice and information; Emily Pazar, curatorial assistant of craft, design, & fashion, must be singled out for her characteristic ability to see the forest *and* the trees, as she made edits and kept PDFs in order.

Jay Everette, senior vice president, community affairs manager, Wells Fargo, supported the idea of an exhibition and book on Long's recent costume designs from the get-go. The Friends of William Ivey Long— Katie Charlebois, Lisa Evans, Noelle Mahoney, Renee McColl, Susanne McGuire, Jo Ann Peer, Susan Rankin, Paige Roselle, Allison Sprock, Leigh-ann Sprock, Ann Tarwater, and Debi Timmerman—provided generous support, friendship, and a lot of fun. Susanne McGuire, community leader, and Jo Ann Peer, immediate past chair of the Mint Museum Board of Trustees, first brought the idea of a project about William Ivey Long's work to our attention. Weston Andress, Tom Gabbard, Susan McKeithen, Laura Vinroot Poole, Ann Tarwater, and Bob Wilhelm have been a part of conversations that have resulted in a better book.

The book reads as well as it does because of Donna Ghelerter, copy editor. Steadfast in the pursuit of accuracy and clarity, she was patient and nimble, easy to work with. Irving Solero, former photographer at the Fashion Institute of Technology, captured sensuous costume and other details in Long's studio. As a design object, *William Ivey Long: Costume Designs 2007–2016* was conceived to be both "useful and beautiful"—to paraphrase arts and crafts designer and activist William Morris—fitting comfortably in the reader's hand and containing pictures and words that seamlessly bring the subject matter alive. Linda Florio's exceptional book design captures the intelligence, textures, and aesthetics of Long's costumes.

Lastly, at Yale University Press, Patricia Fidler, publisher, art and architecture, and Roland Coffey, publishing assistant, art and architecture, recognized the broad appeal of *William Ivey Long: Costume Designs 2007–2016*, and worked collaboratively to promote the publication.

I am deeply grateful to all of the above, and honored to have worked with such incredibly gifted and dedicated individuals.

Annie Carlano
Senior Curator of Craft, Design, & Fashion
The Mint Museum

104150